MISTY
COPELAND
BY
GREGG DELMAN

MISTY COPELAND

BY
GREGG DELMAN

FOREWORD BY
MISTY COPELAND

RIZZOLI
NEW YORK

New York · Paris · London · Milan

FOREWORD
By Misty Copeland

You've heard the saying, "A picture is worth a thousand words." In my opinion, those words are so true. A picture can take us back to the very moment that captured what we now saw, as if time has stood still. We get to experience what the photographer thought was so important, so critical about what the lens revealed that if we are open to it then we can go on a visual journey through time. Simply put, pictures tell many stories.

Although ballet is movement, it's also an incredibly visual art form—we tell many stories with our bodies. When photographing dancers, it is important to capture the nuances of our bodies as they transform from one movement to the next, without missing the overall arc of the movement. Nothing is more troubling to a dancer than an image that does not reflect the true intent of the movement. A photographer who understands how to memorialize a moment in a dancer's journey has a gift, and it is a gift to work with them, as this kind of photographer is rare. I also like an environment that allows me the freedom to create as though the camera is my audience. Gregg Delman has been a unique audience, yet a subtly creative participant, both inviting and warm; he has that rare gift of capturing movement.

Gregg and I met in 2011. Although he was not as known for photographing dancers, he took beautiful images and had an impressive resume with a long list of high-profile subjects he'd photographed. Because of the unassuming simplicity in our preparation, I didn't expect to see the exceptional classic beauty that was consistently created in our photographs, and I was blown away by how full and finessed the end product always was. For the majority of our shoots there was no glam squad or walls of wardrobe—I did my own hair and makeup, wore my own clothes, and just like that, we'd get to work.

I knew from the beginning that we had started what would be a long collaborative relationship. Having since done over a dozen shoots just for fun, we now have a broad range of rare and timeless images that are being seen for the first time in this book. I couldn't be more proud.

INTRODUCTION
By Gregg Delman

I have to admit that when it comes to ballet I am a bit of a neophyte. In fact, the only ballet I ever attended was *The Nutcracker* on a field trip back in elementary school. Sitting high in the balcony, I was captivated by this new kind of experience, and I wanted to be closer to the stage. I grew up watching MTV and the Yankees, but going to a ballet was completely out of my box yet it made a huge impression on me. Even though I wasn't quite able to put it into words at that time, I was completely moved by the spectacle and the production of it all: the lights, the costumes, the juxtaposition of strength and grace in these obviously disciplined athletes, and also by the power of this voiceless narrative. I like to think that this single experience set the foundation for my interest in the arts, and I now use the medium of photography every day to capture body language, expression, light, and so many other things that I first saw at that ballet.

My first glimpse of Misty was in 2011. Flipping through the pages of a magazine, I was immediately struck by a photograph of a woman standing center stage, poised and chiseled like a marble sculpture you would see in the Met. In my portraits, I try to arrest the essence of a person, their personality, their talent, and that inexplicable *thing* that draws me—and a larger audience—to them. In this case, it wasn't Misty's pose or costume that held my attention, but her gaze. Certain faces tell incredible stories, and as a photographer it is my job to finely tune my eye to see these faces. One look at Misty and I intuitively knew she was special. I needed to know more.

I cold called Misty's agent, the wonderful Gilda Squire, multiple times, and one day I got a response—Gilda said that Misty liked my work but she was only available on *one* particular day at *one* particular time, so I immediately rescheduled my week to make it happen. The first session was in September of 2011, and since then we've met a dozen or so times, and each session was a dream—Misty is such a force, and I am constantly in awe. While only 5'2", she fills a room like symphony orchestra music. Her beauty is matched by her enthusiasm, elegance, polish, and dedication to her art. With every step she epitomizes grace.

Capturing that kind of passion in a photograph can be more difficult than it seems; while a still image can only move emotionally and not physically, a dancer has the ability to do both. During my many years as a photographer, I have spent hours and hours attempting to capture my subjects in body and mind, making the act of viewing my work a transcending experience. Over the four or so years that I have photographed Misty, I've found it very natural to capture her movement and her soul, and that only comes out when a subject is able to be fully themselves as Misty has been able to do in our sessions. This experience for me has been like having a front row seat, and I hope these works take you a little closer, too.

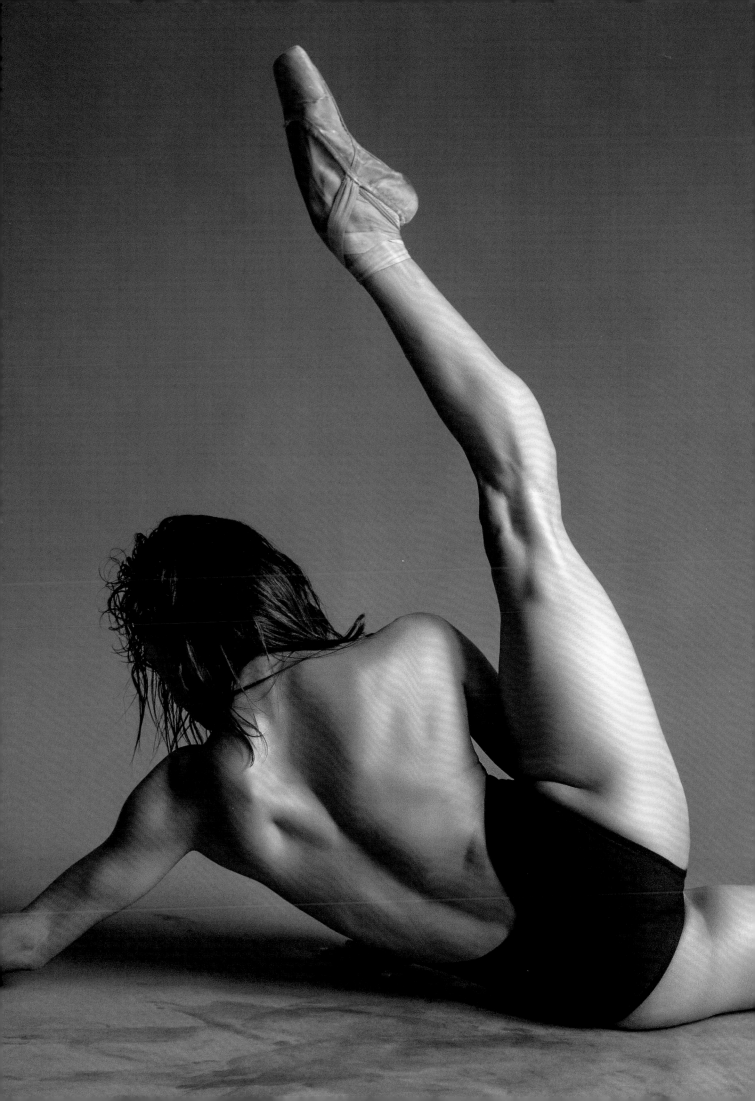

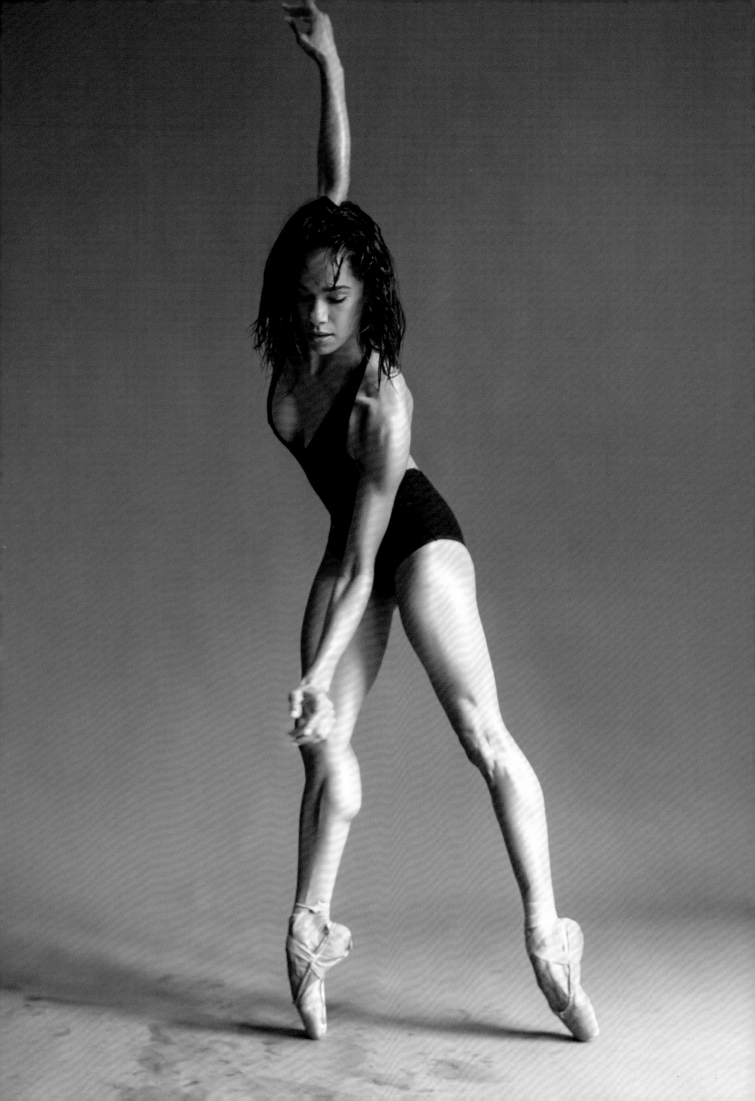

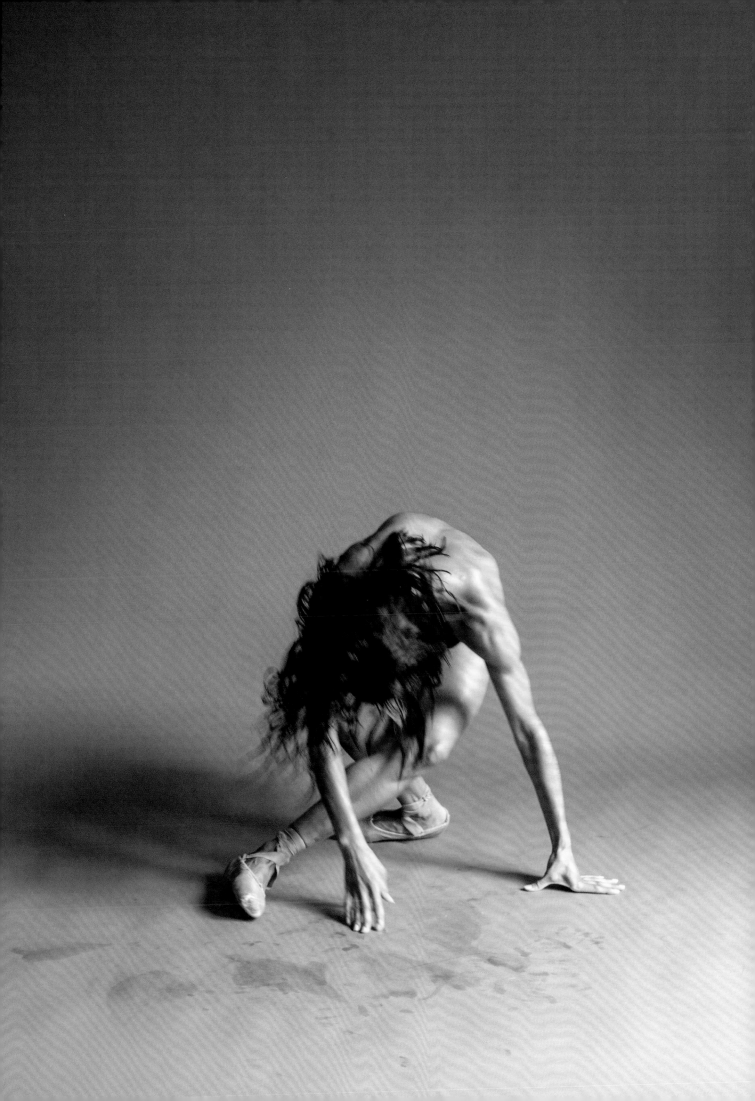

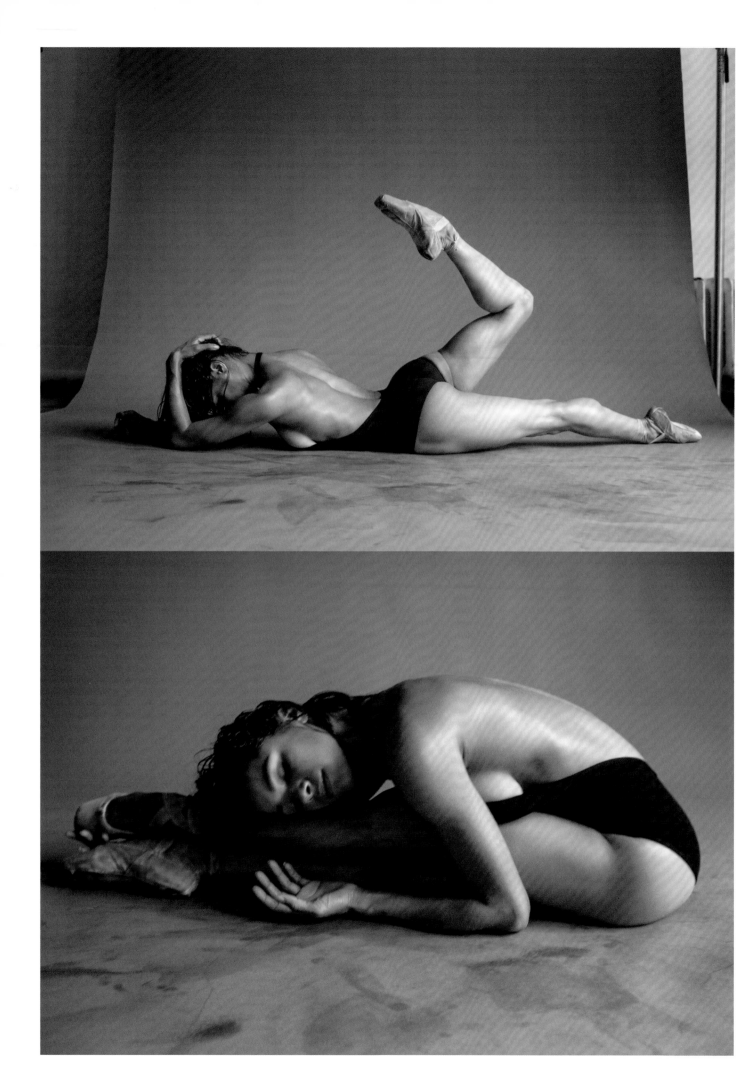

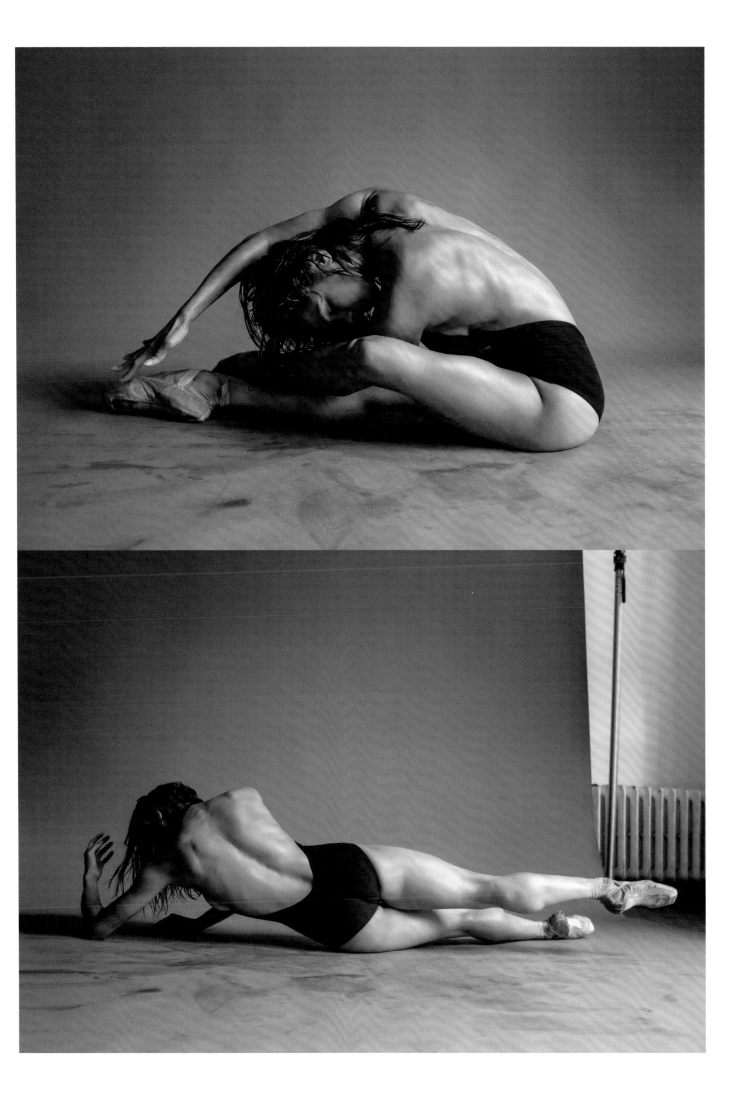

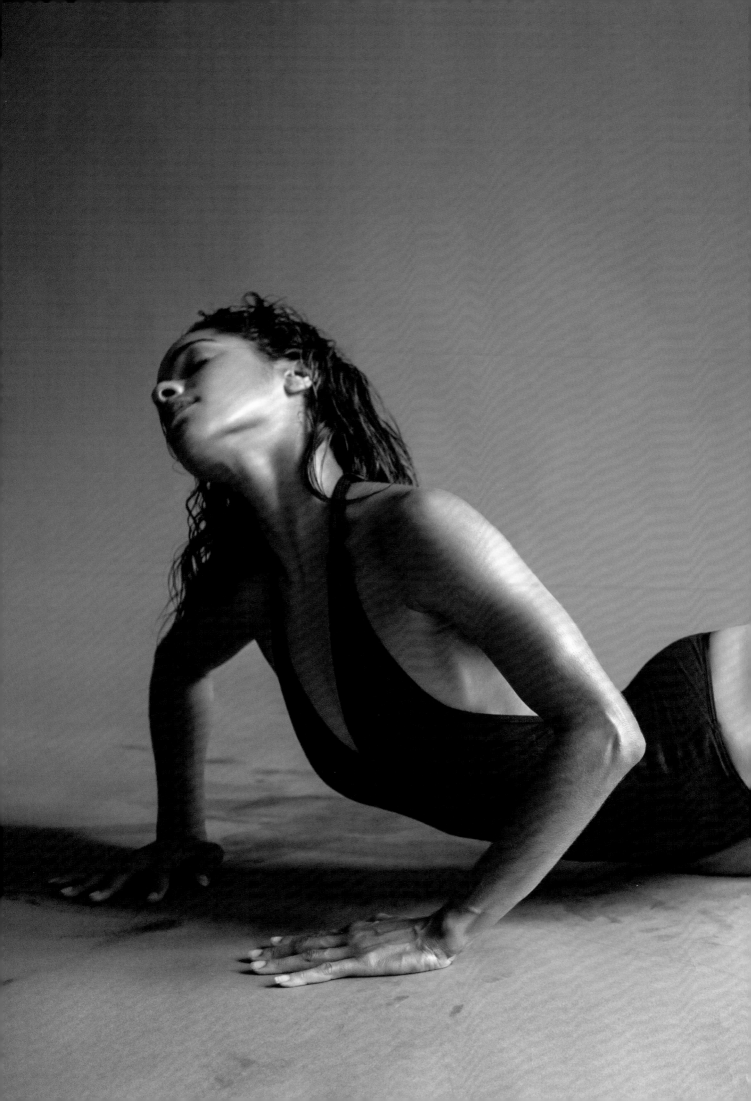

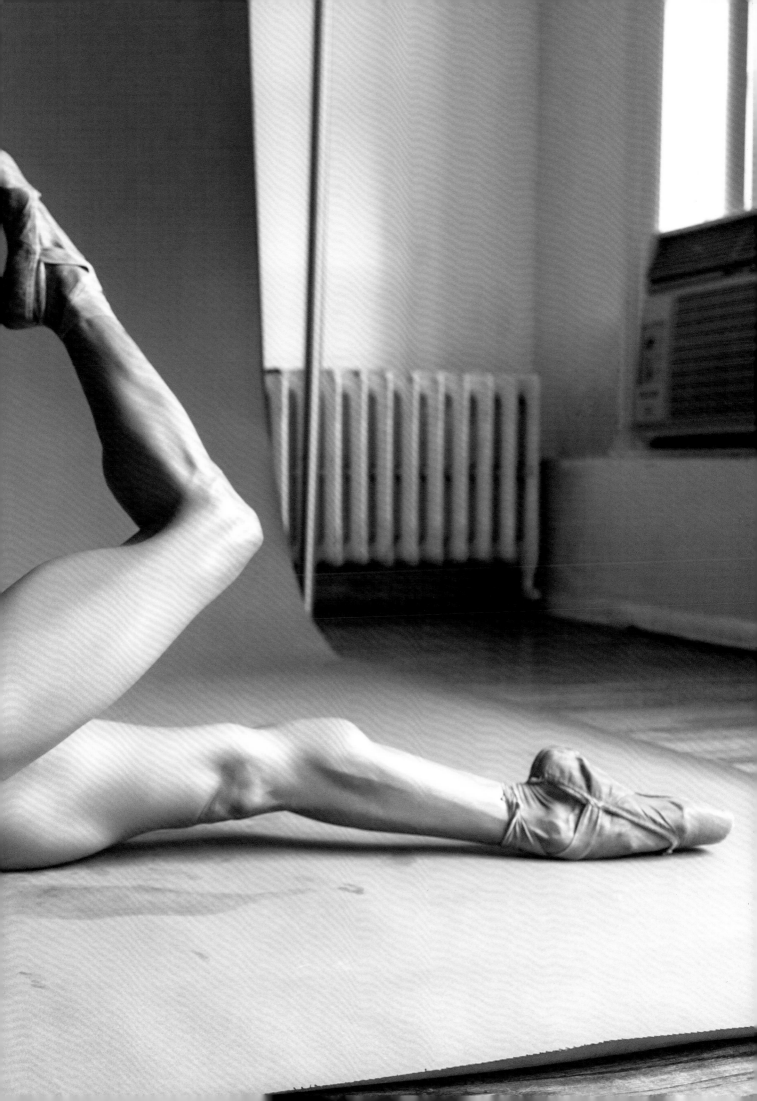

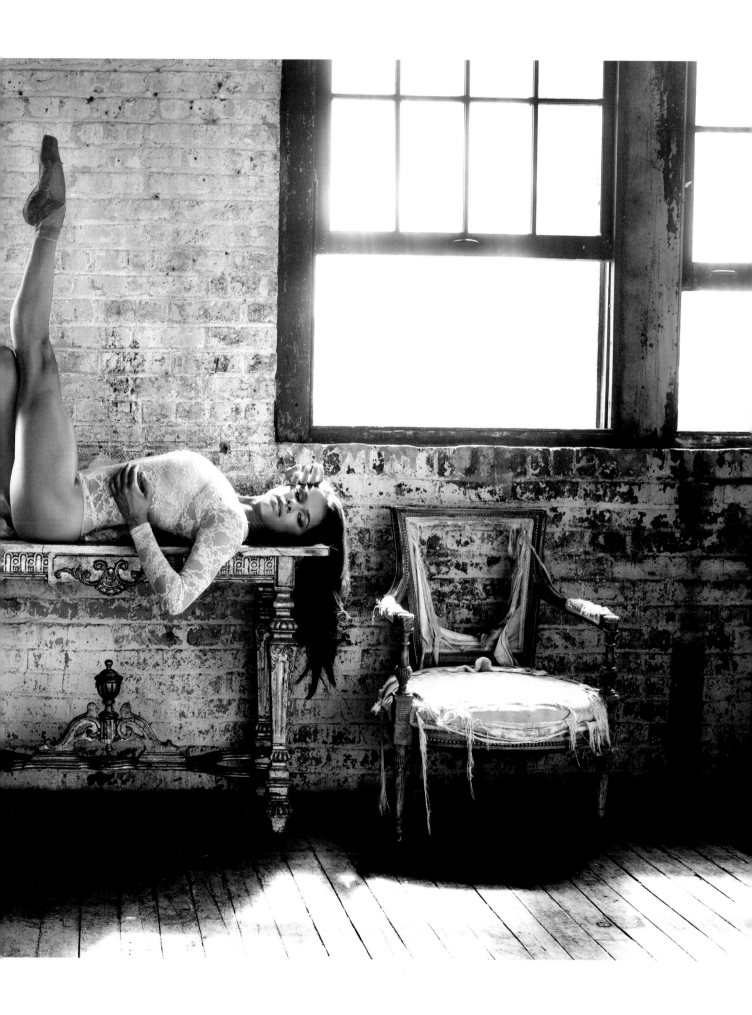

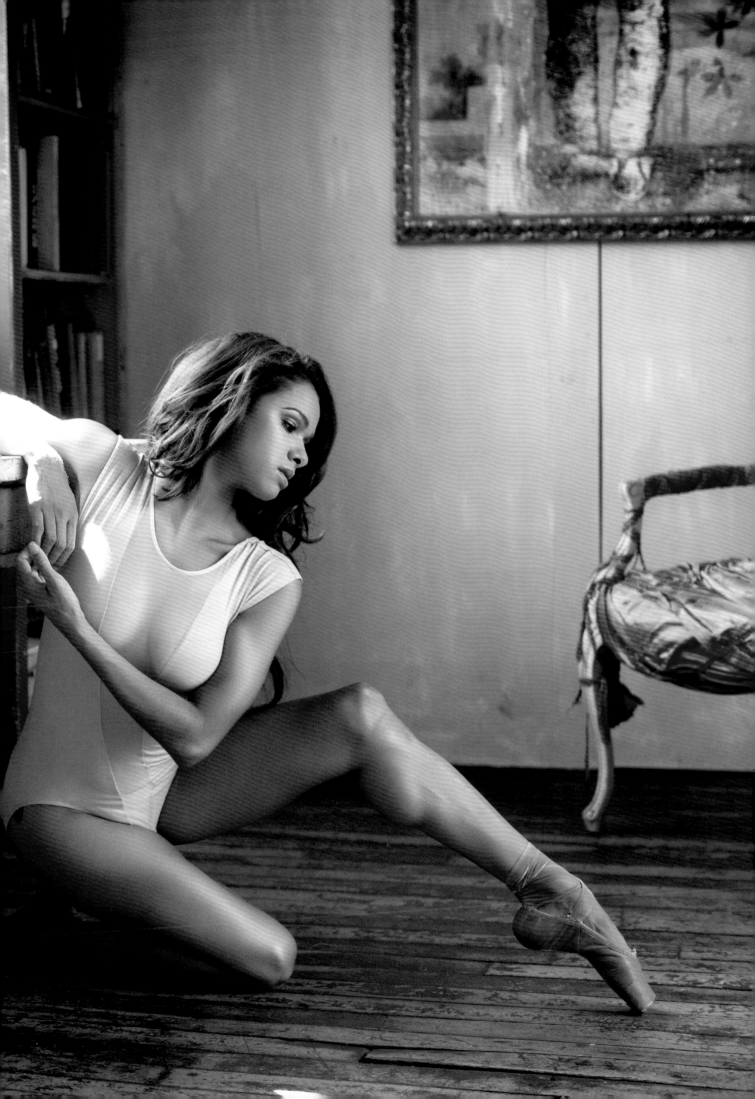

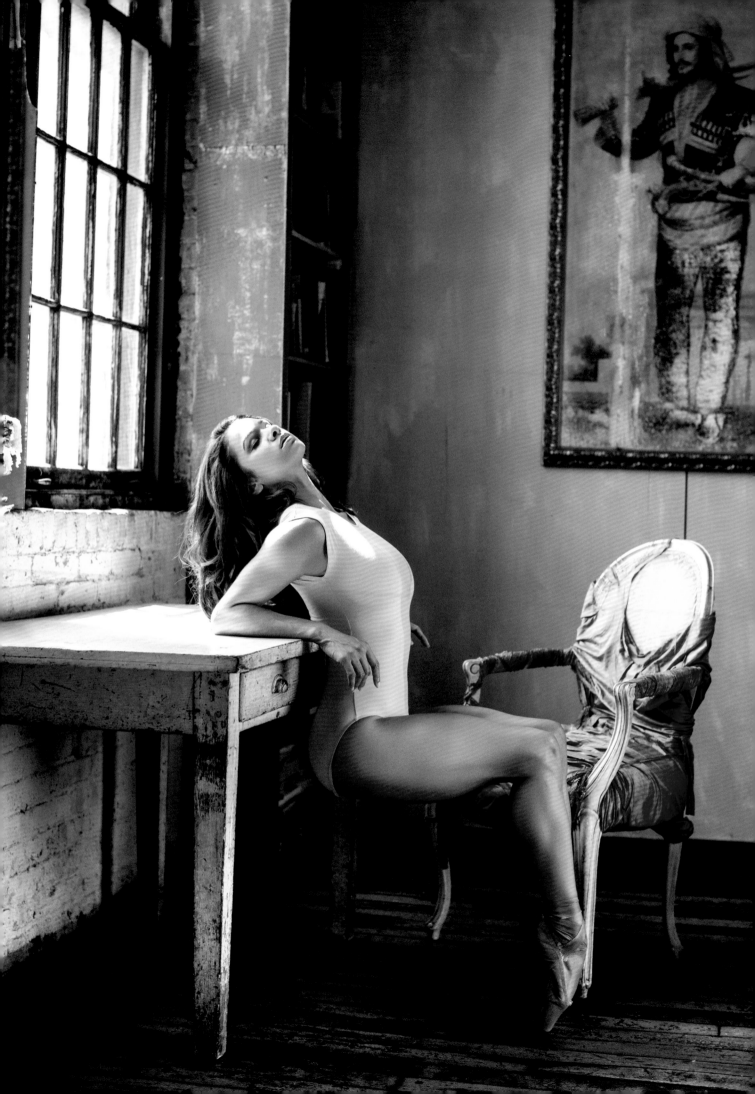

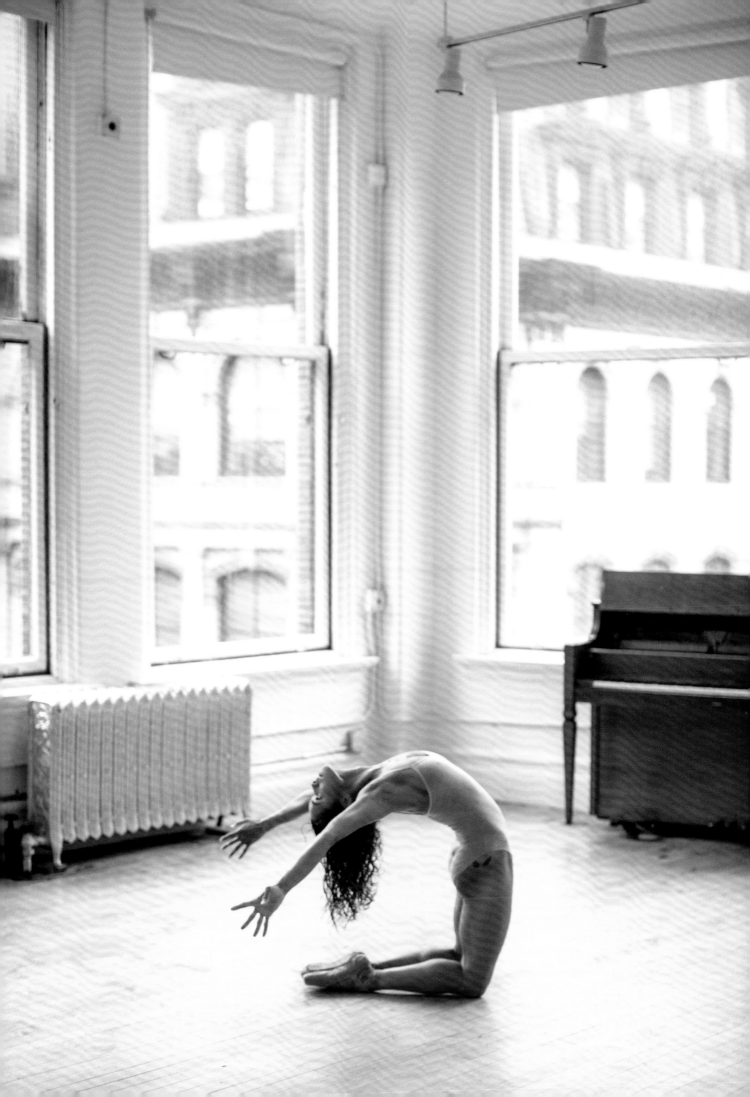

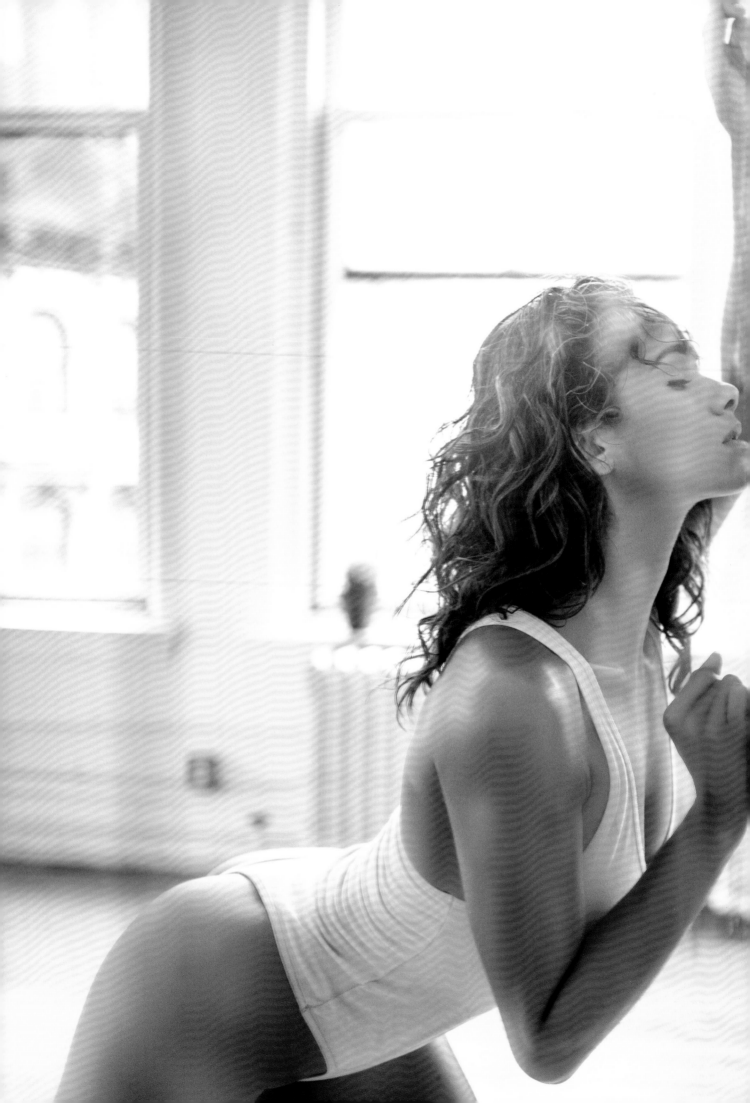

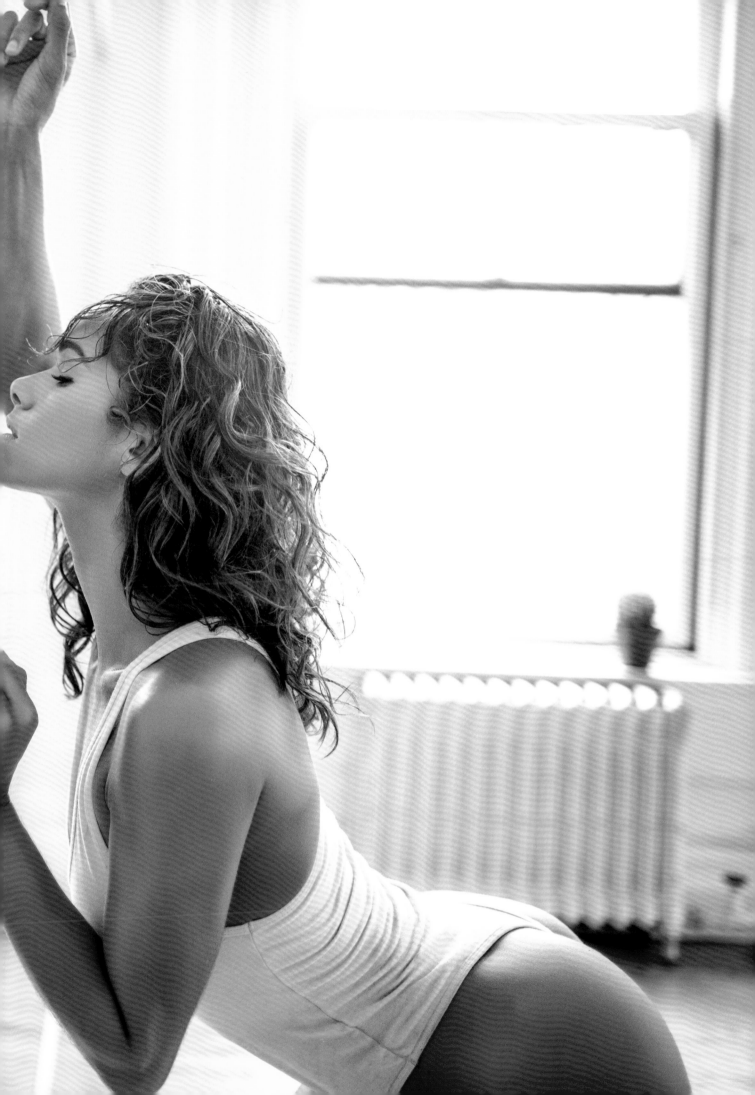

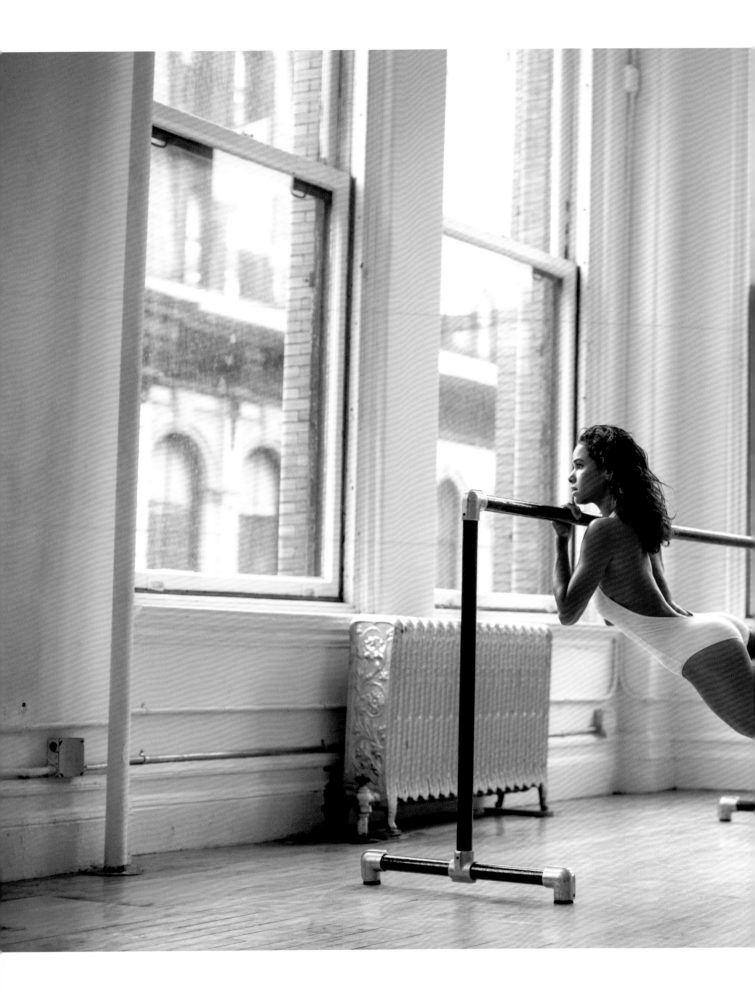

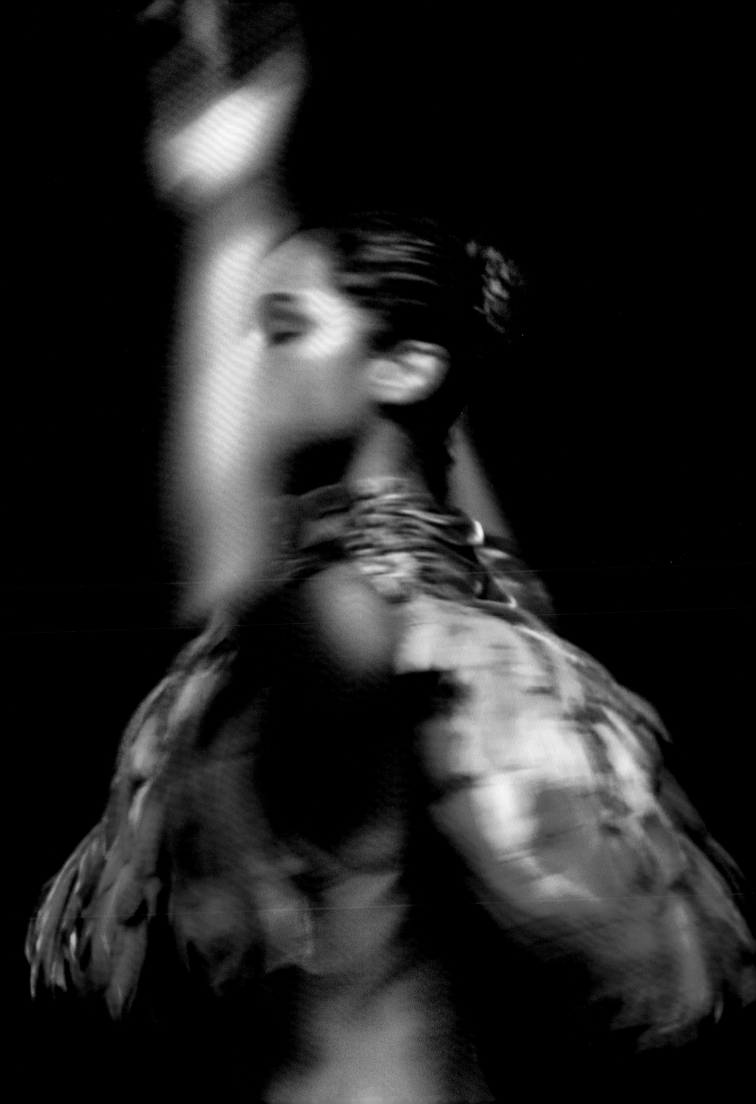

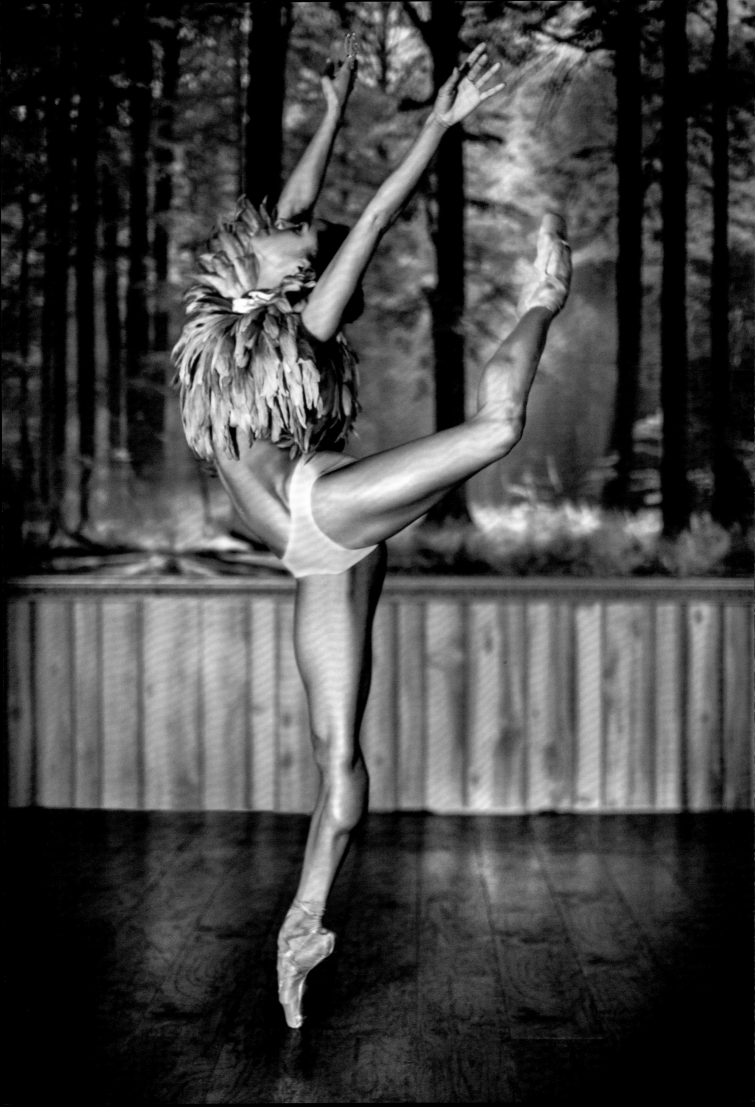

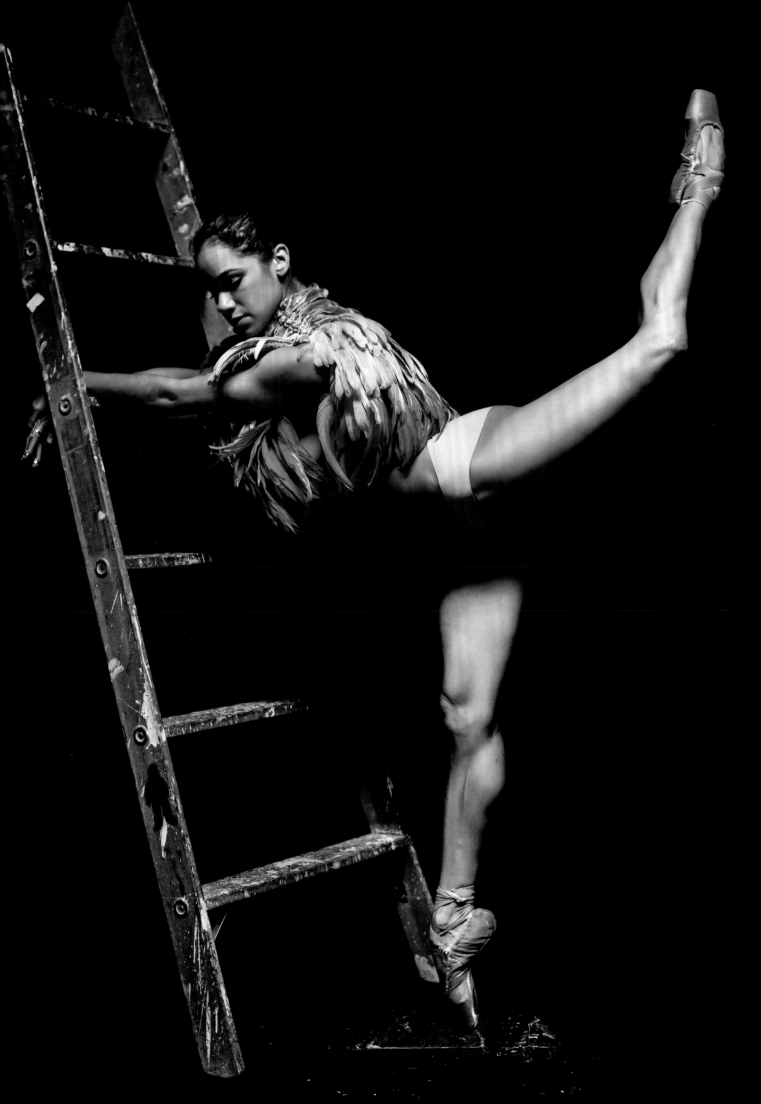

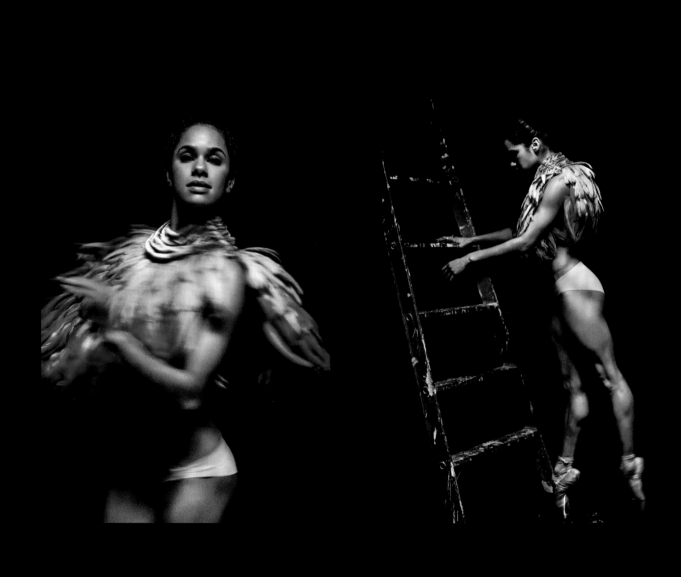

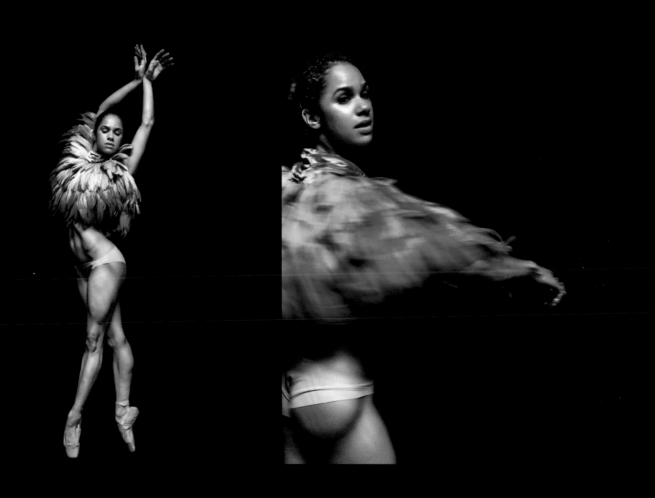

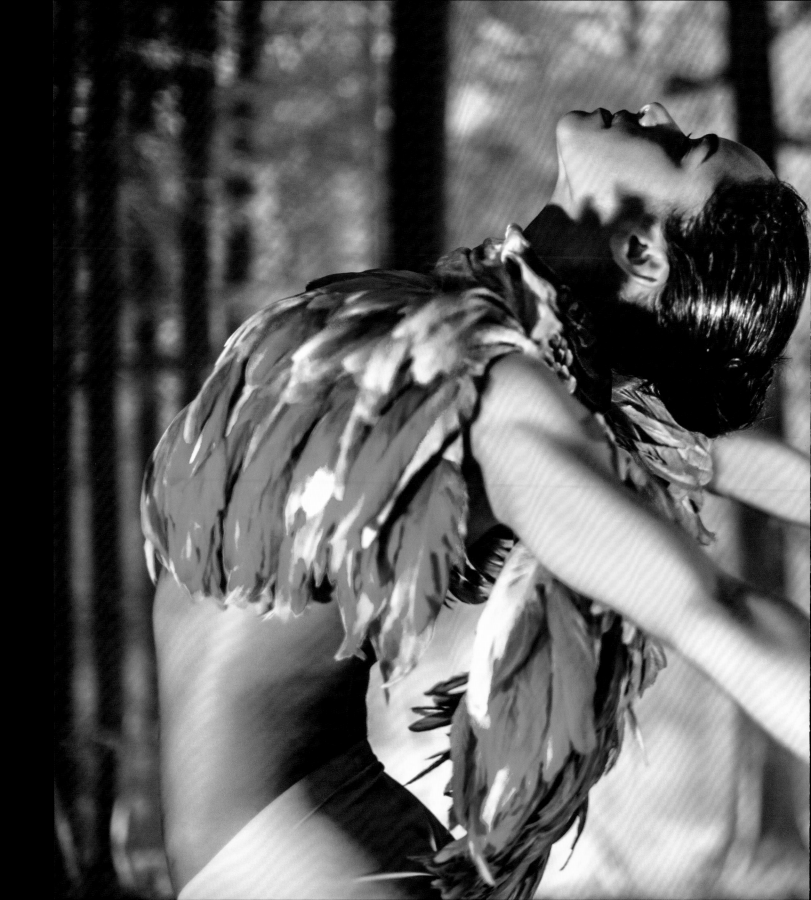

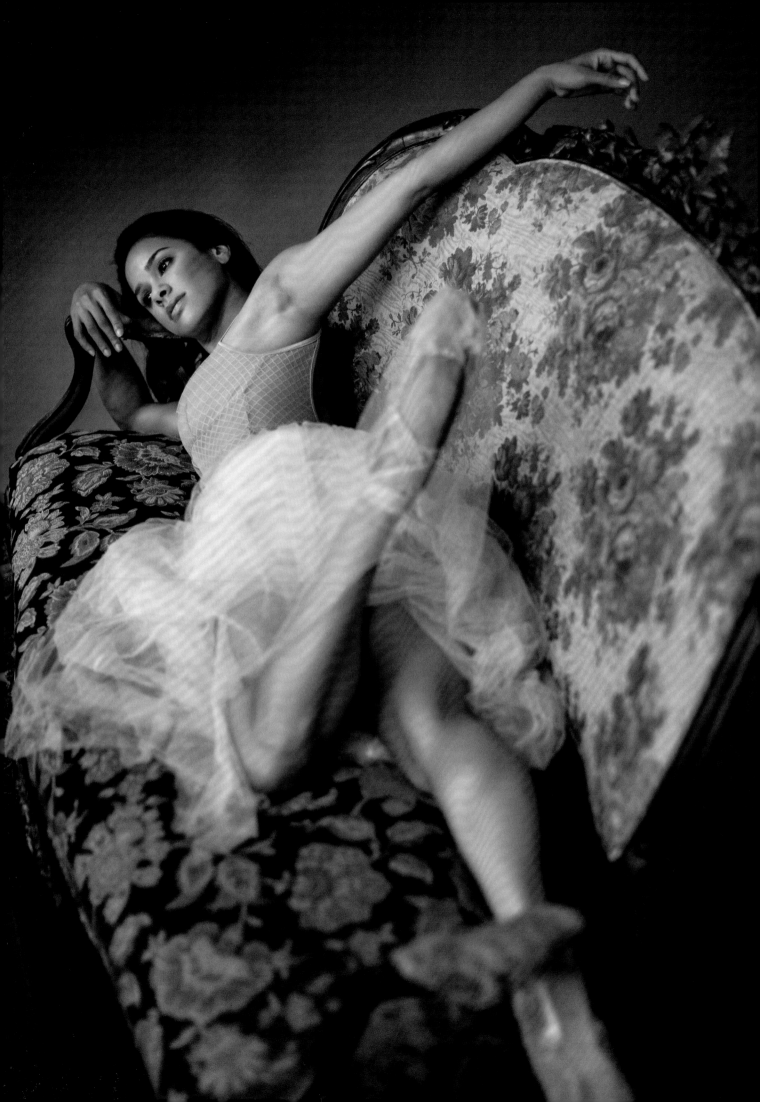

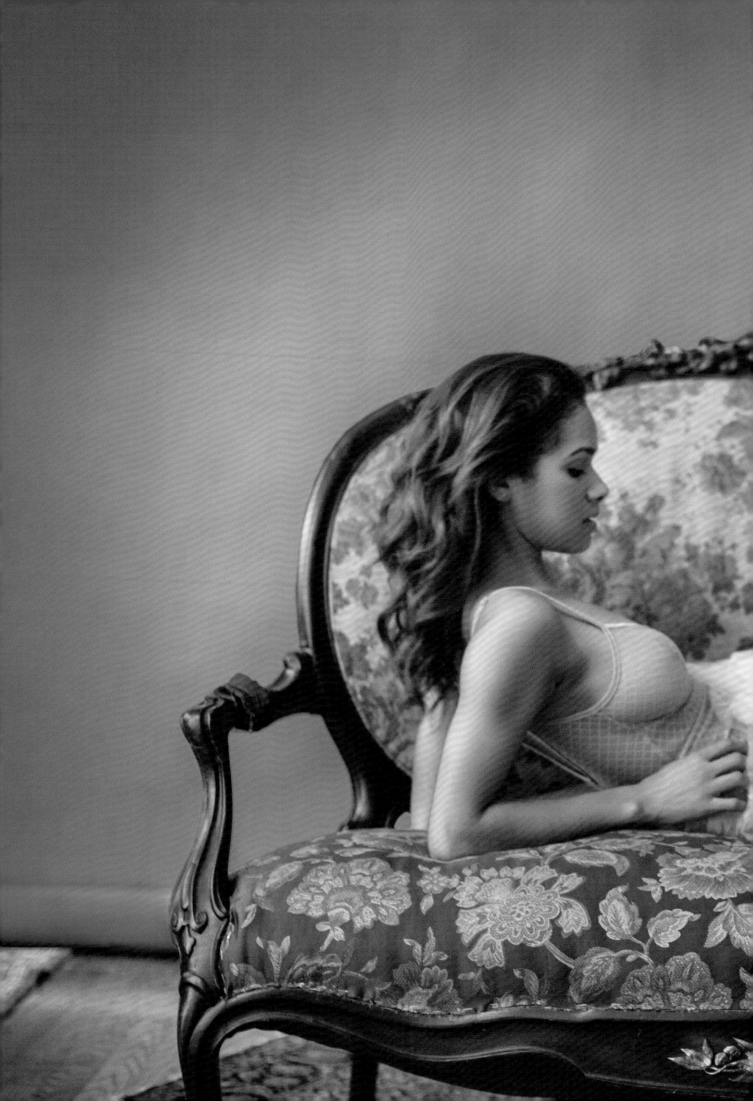

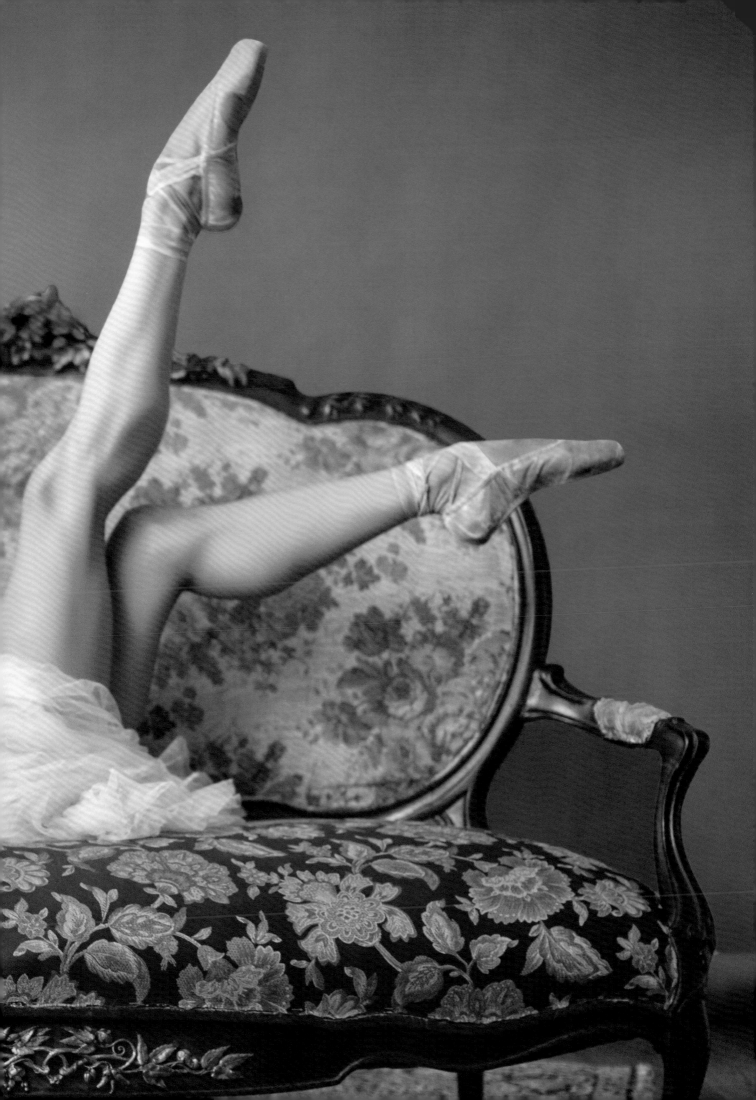

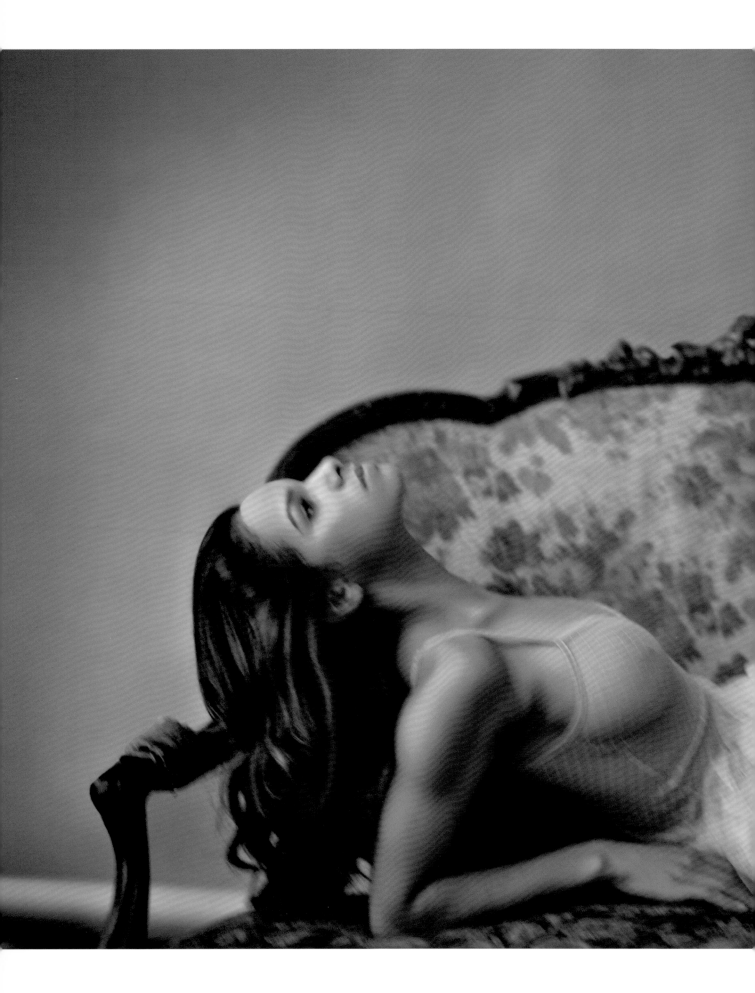

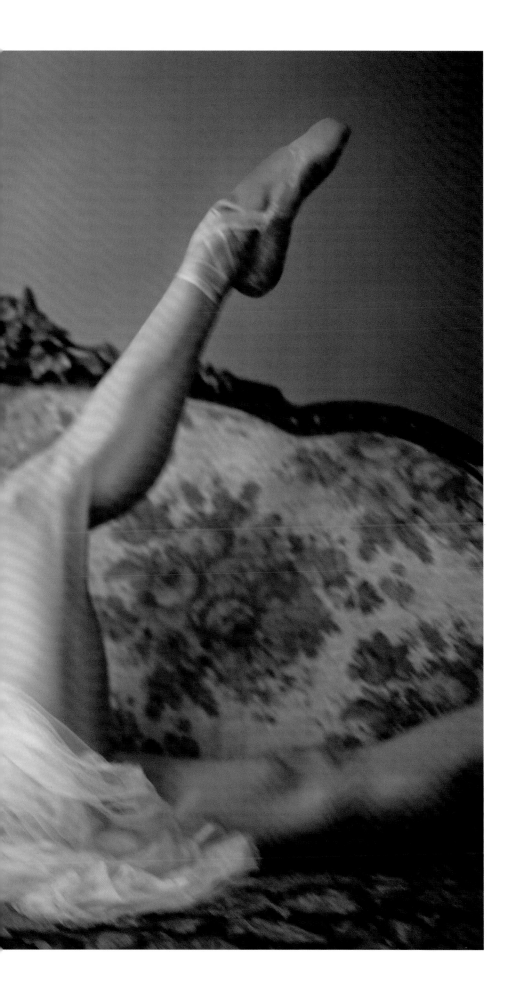

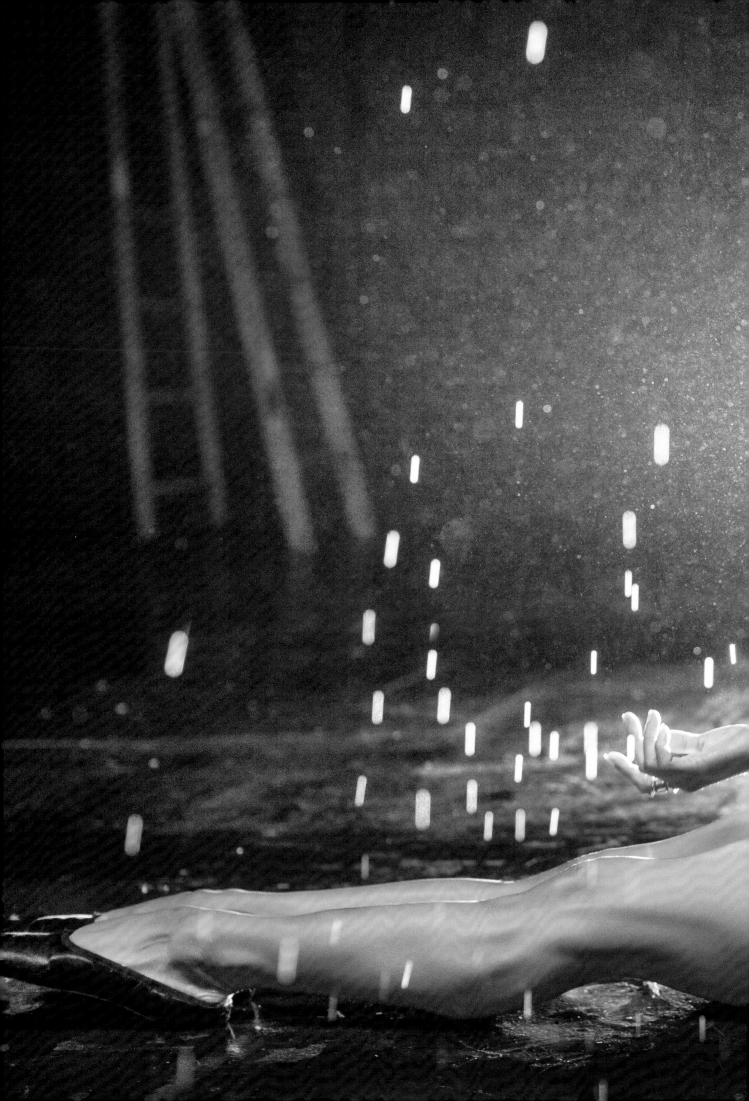

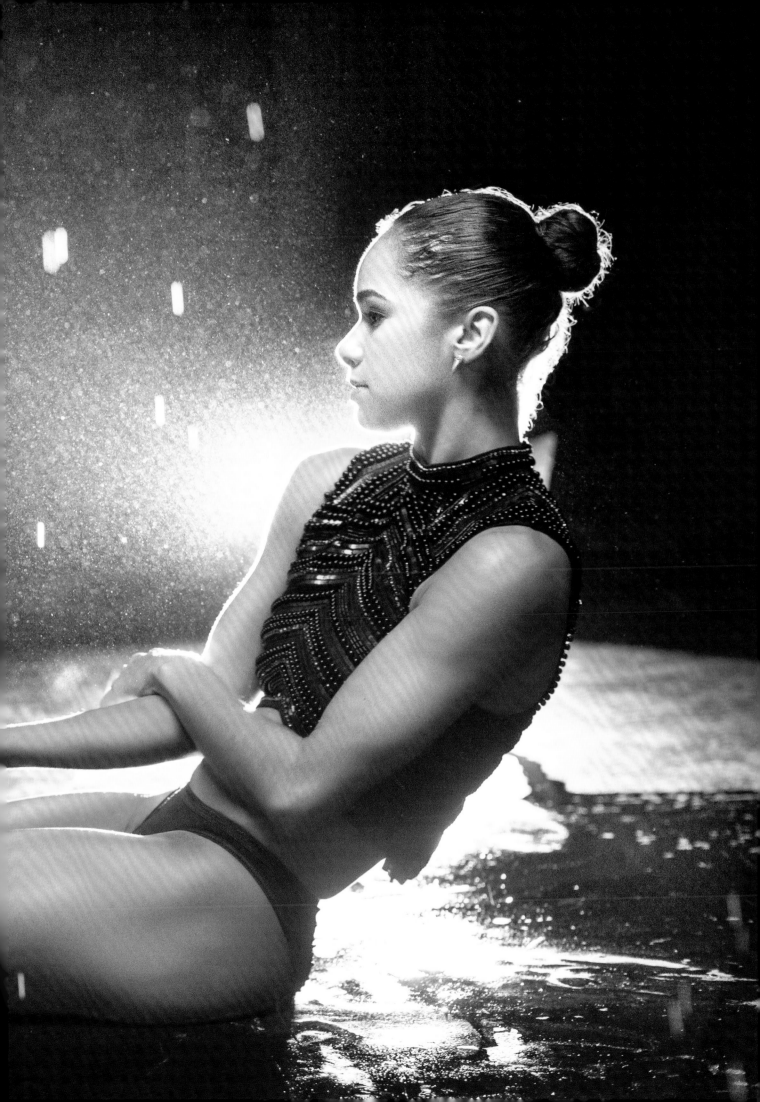

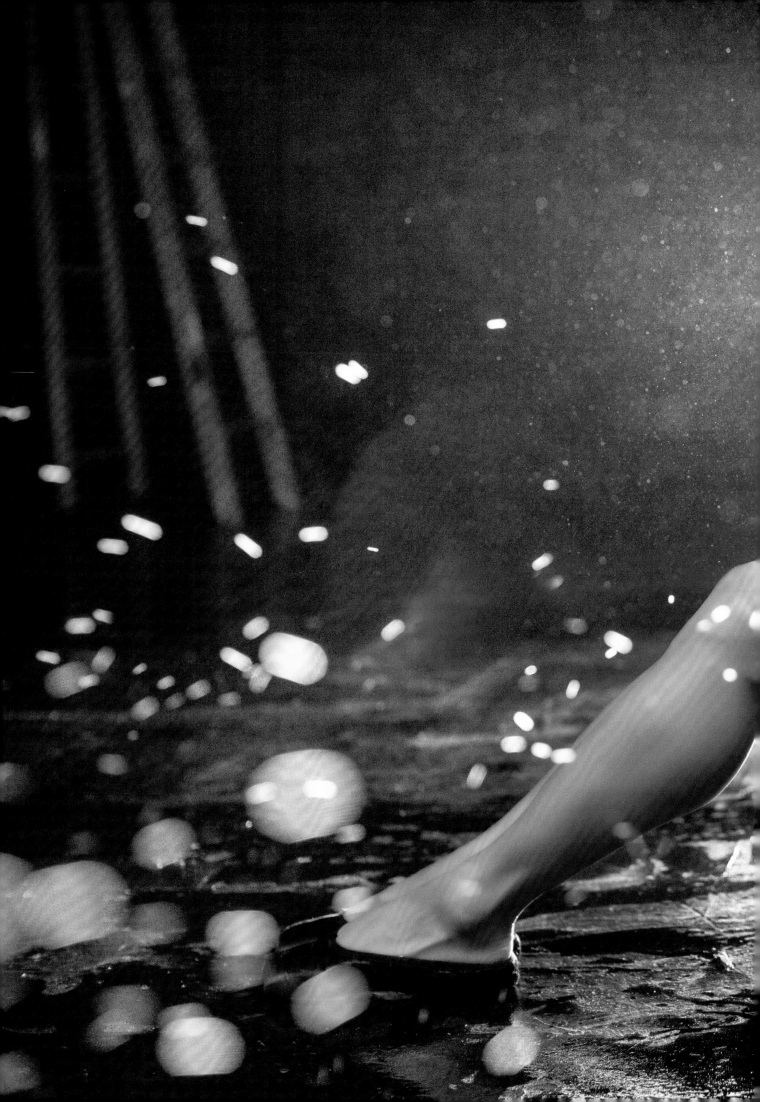

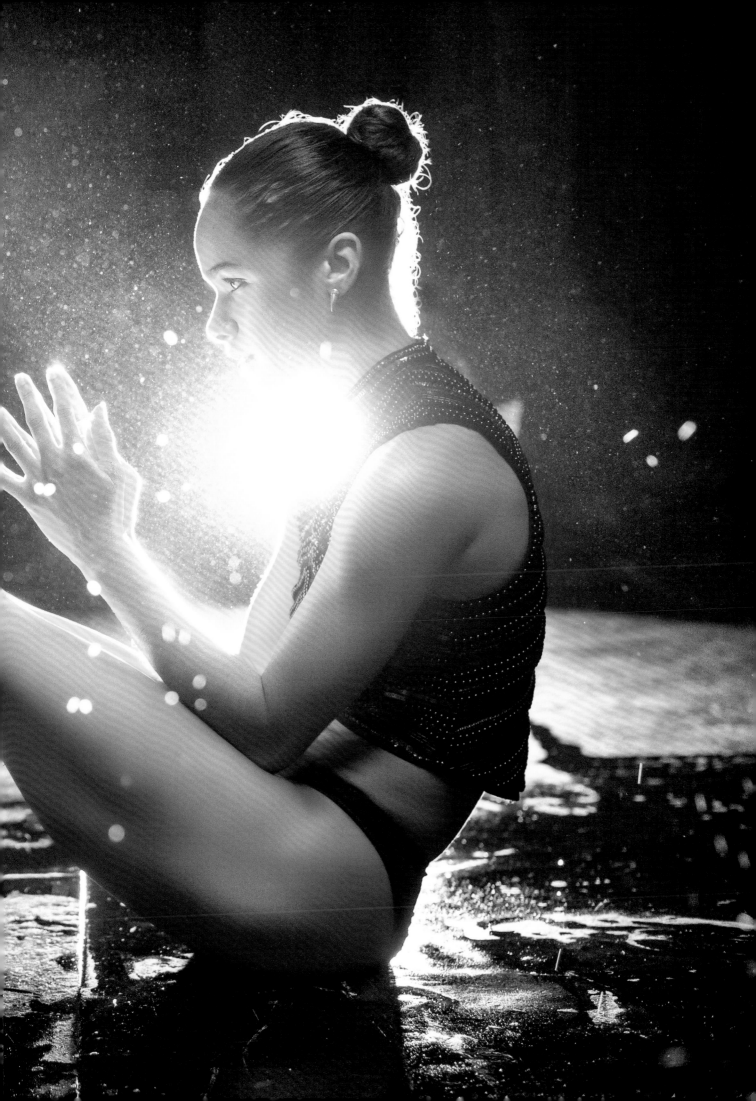

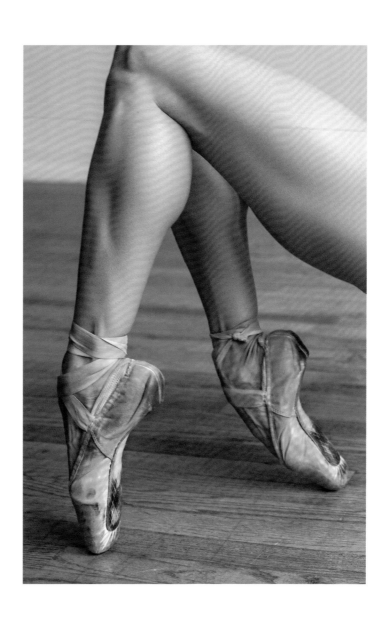

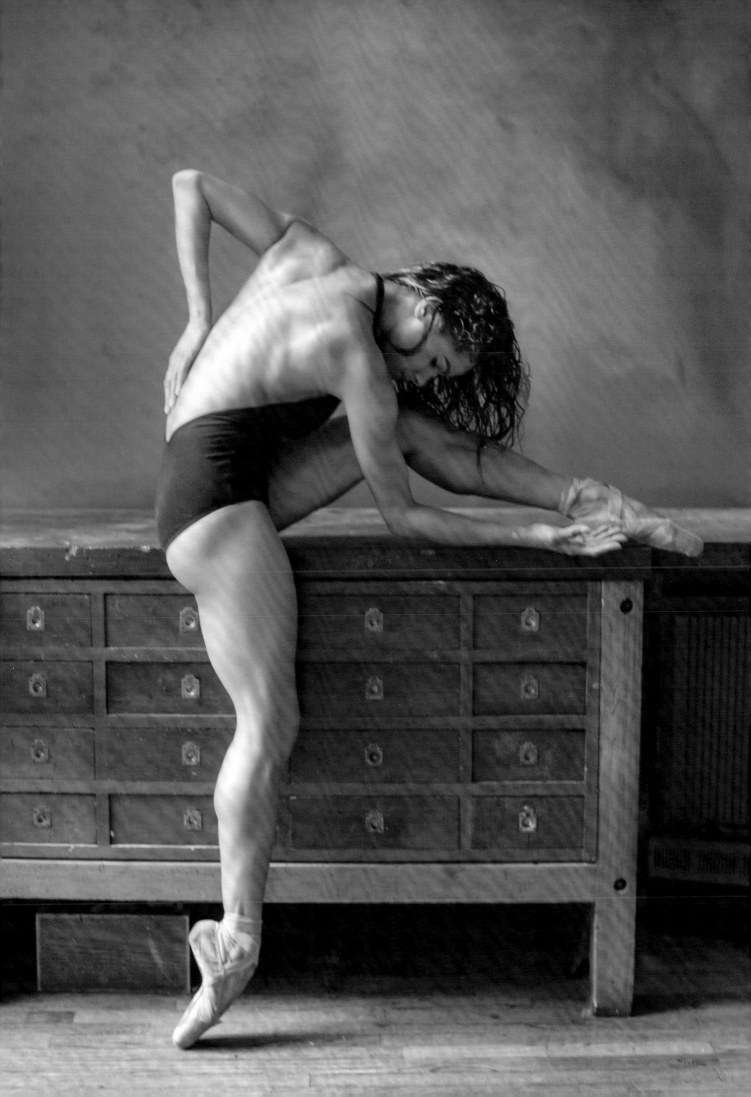

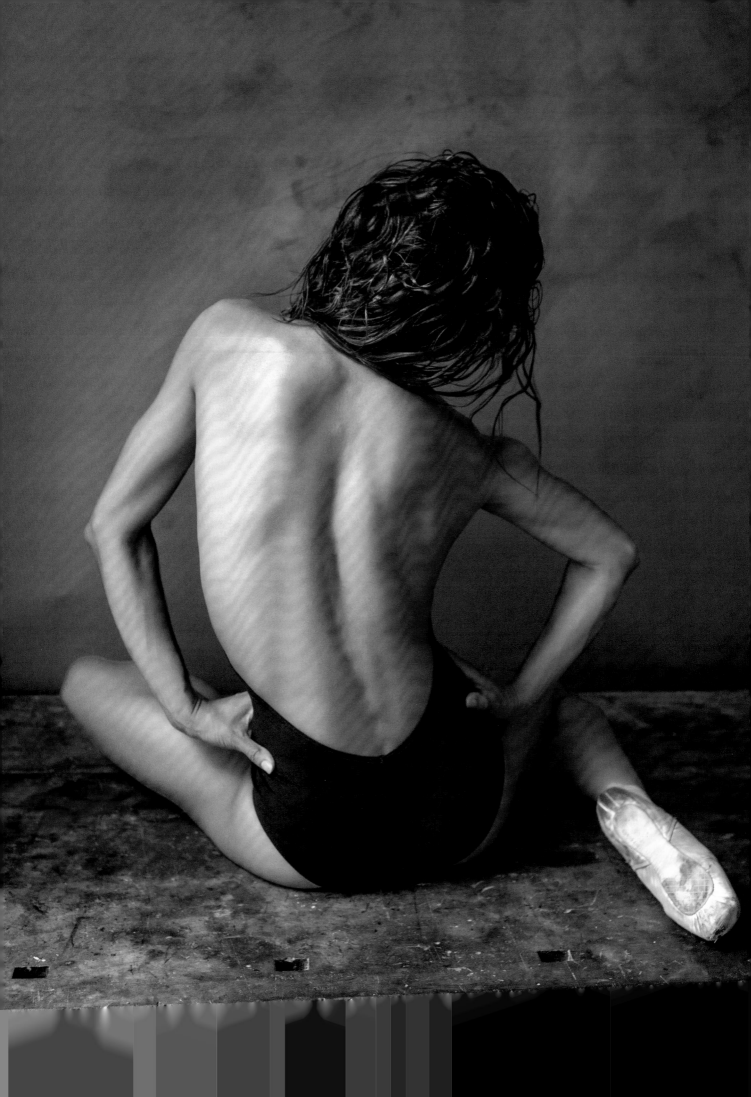

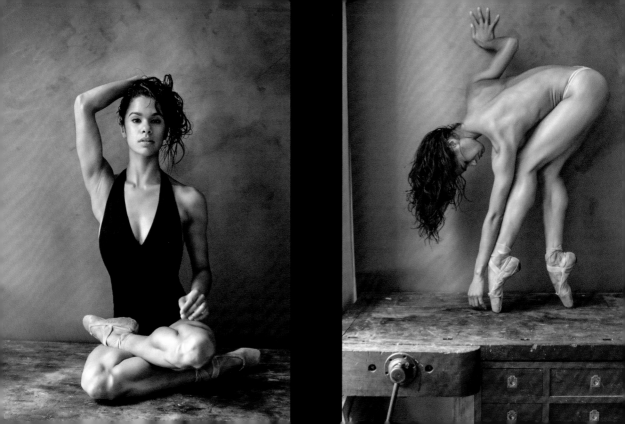

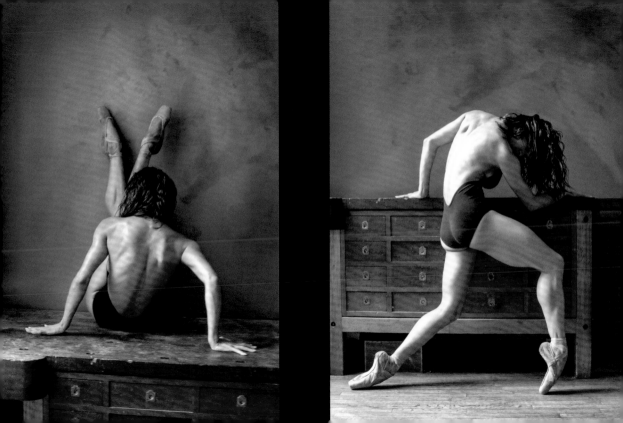

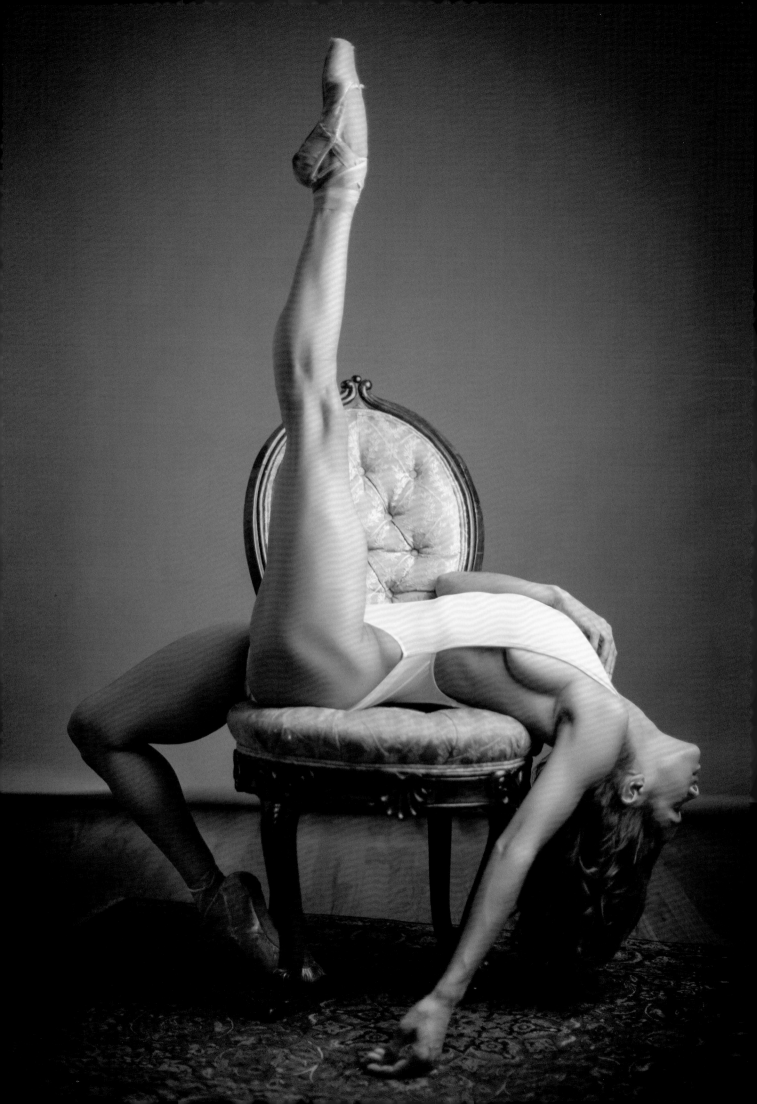

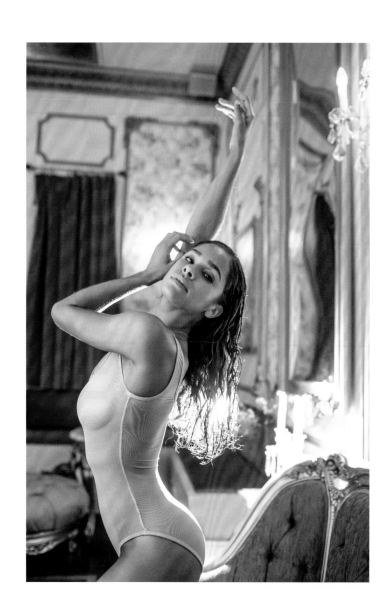

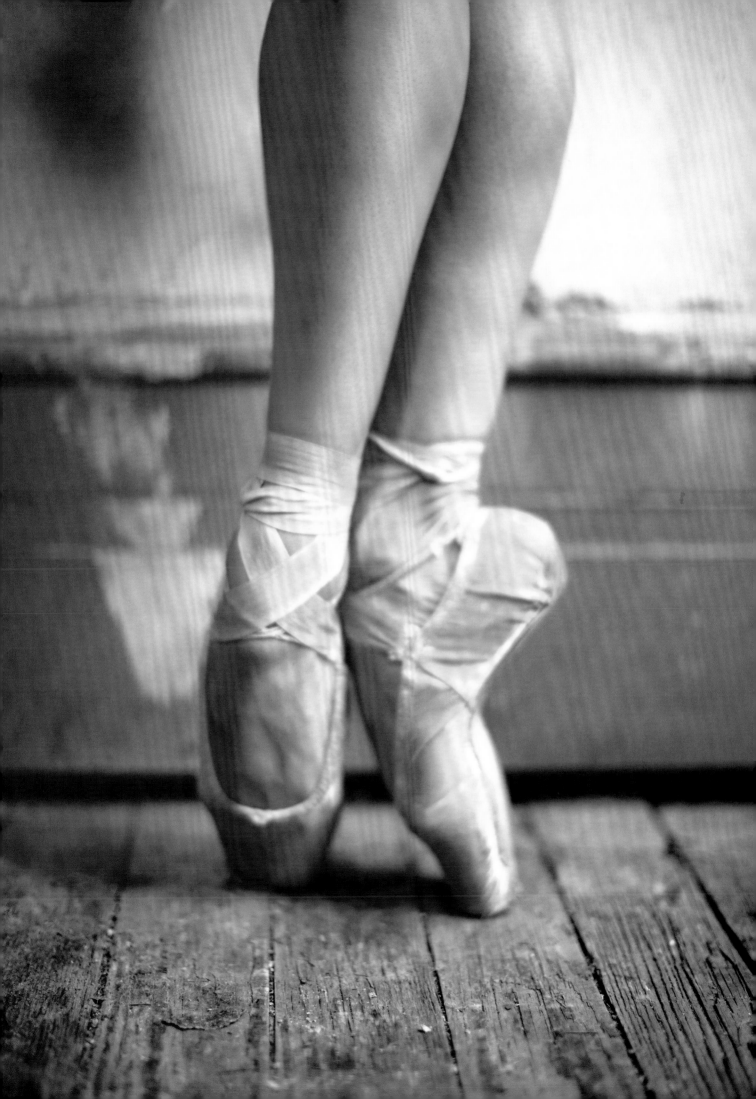

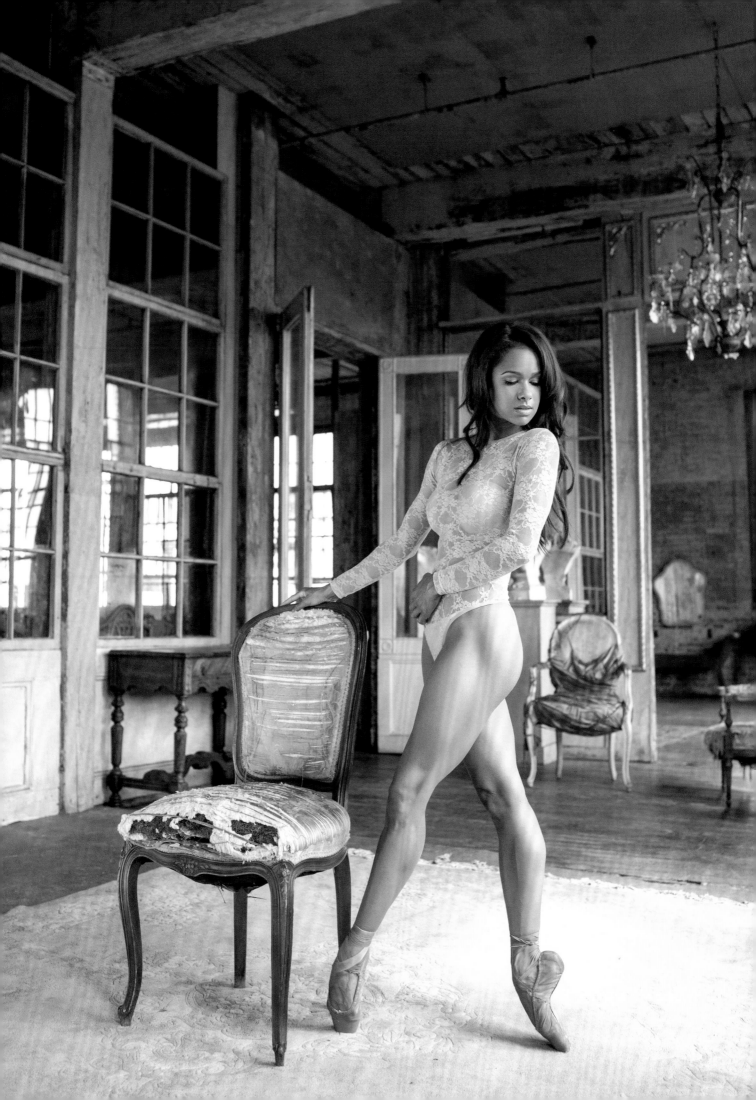

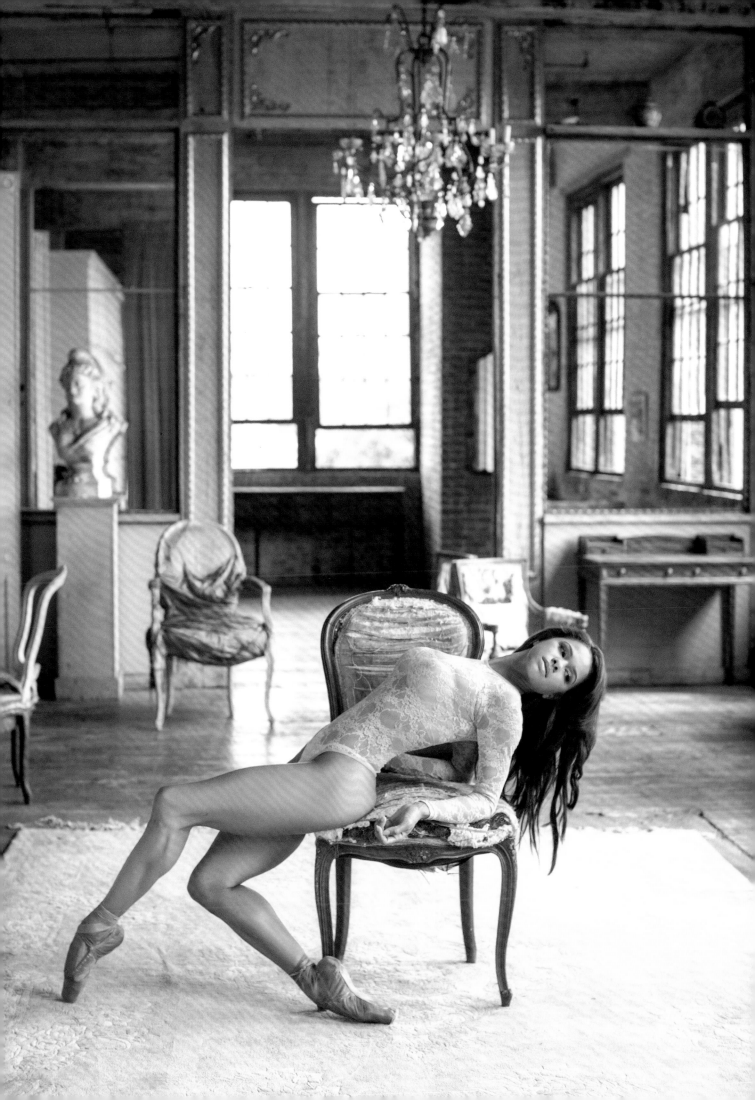

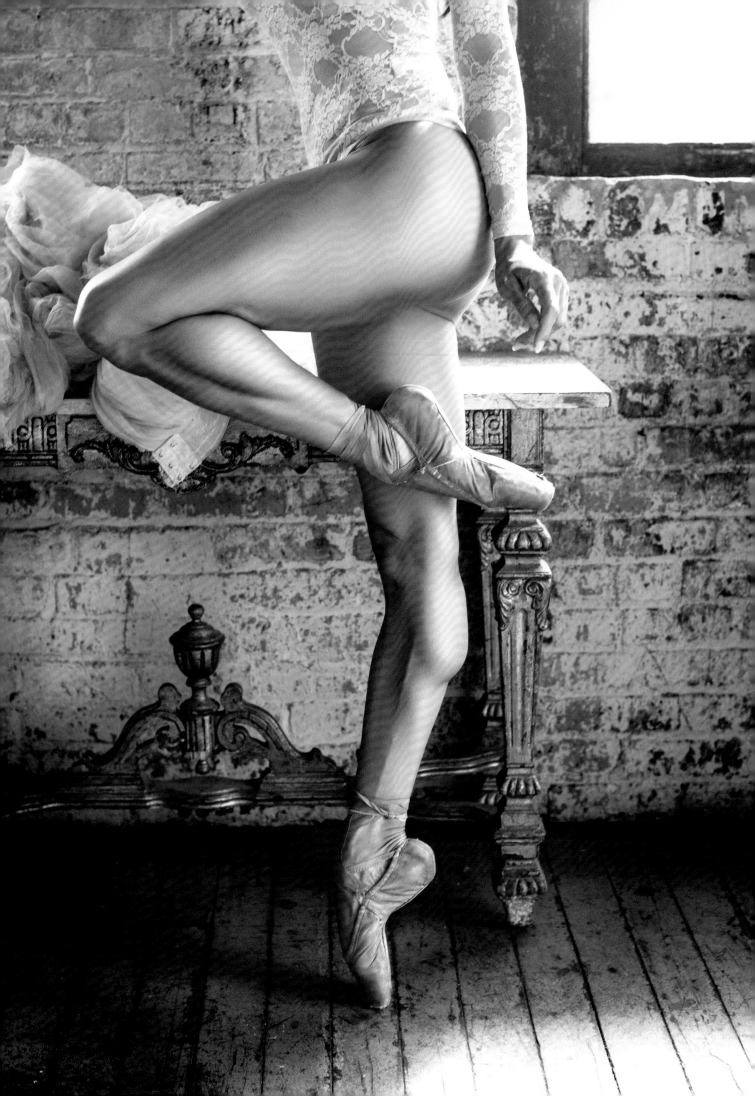

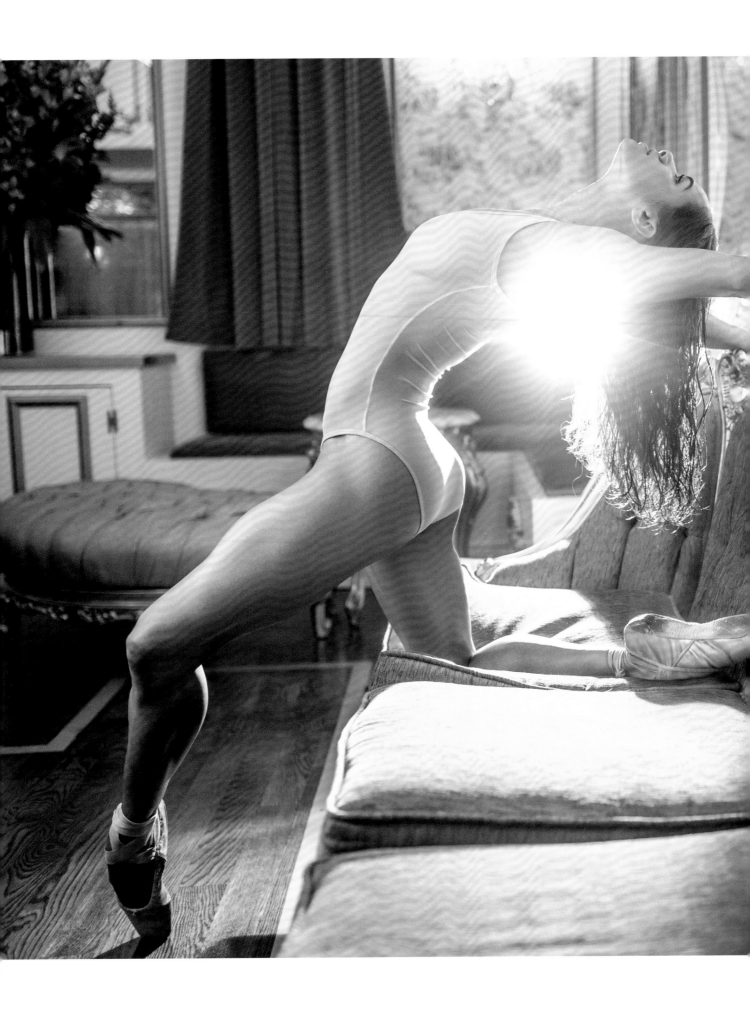

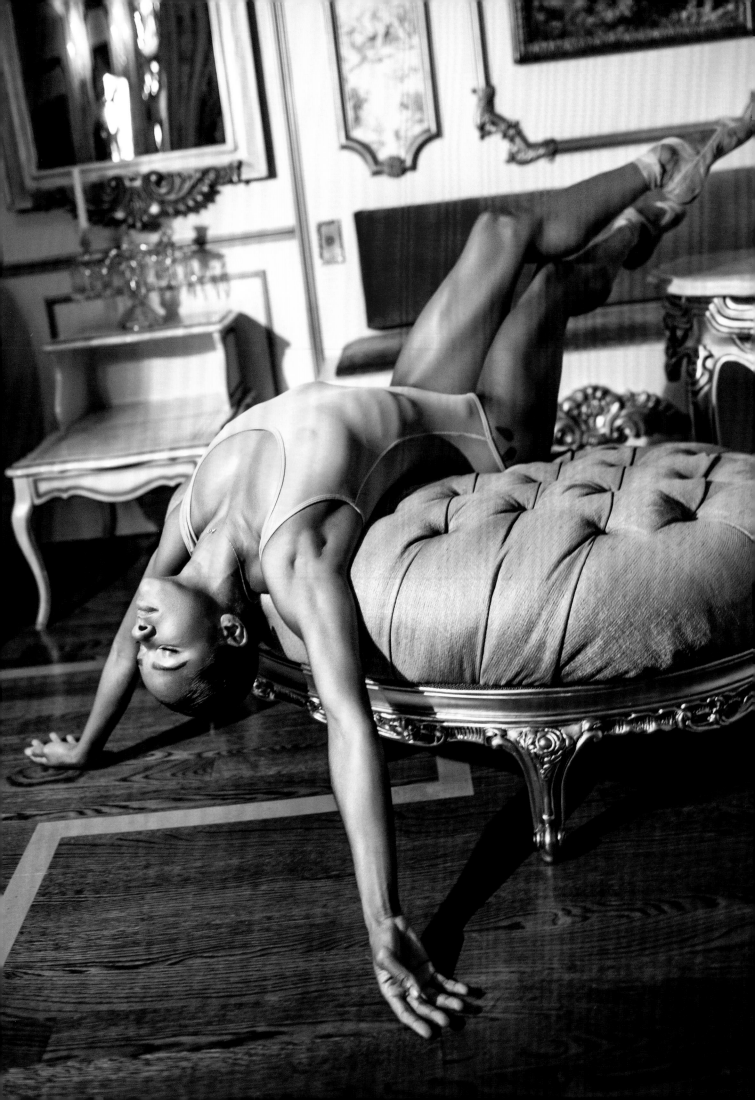

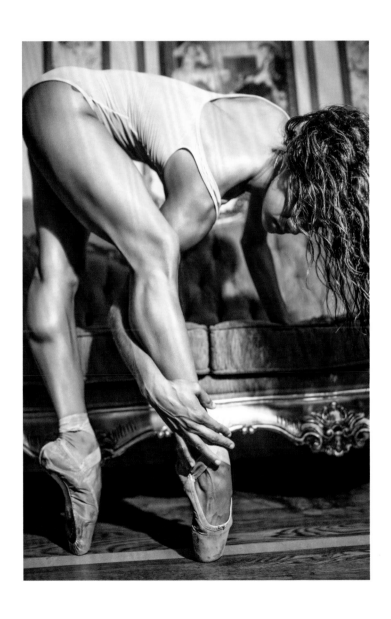

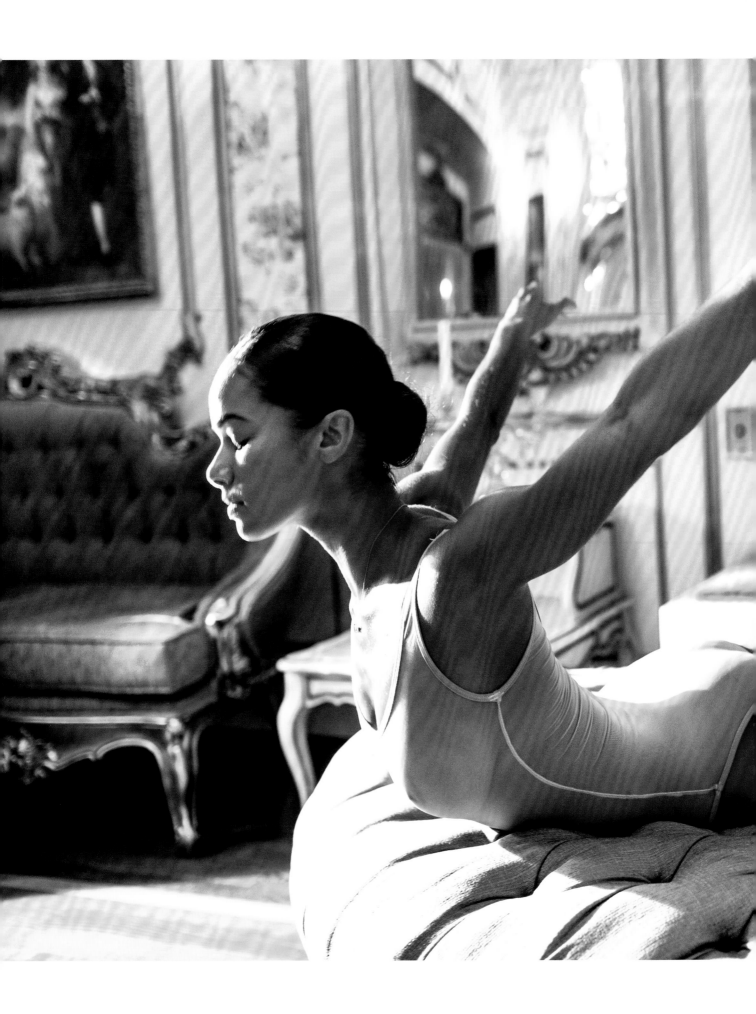

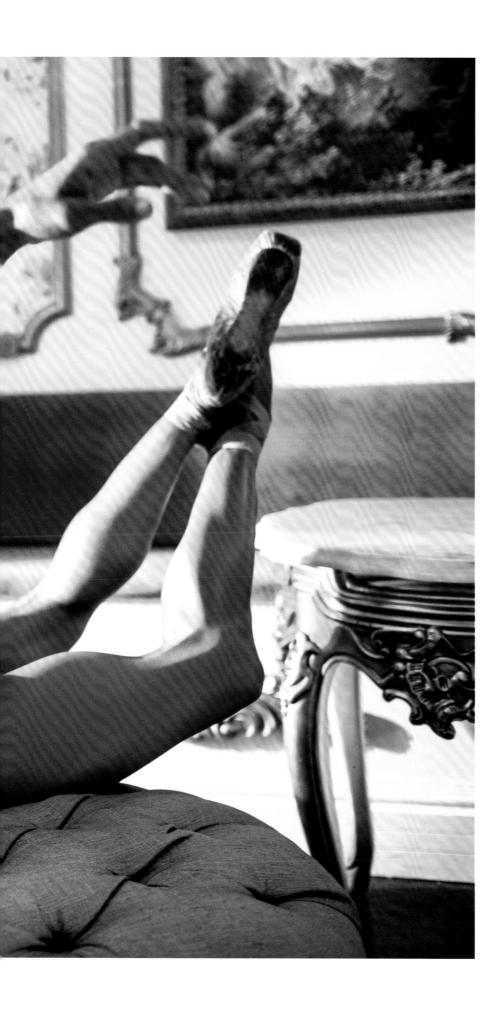

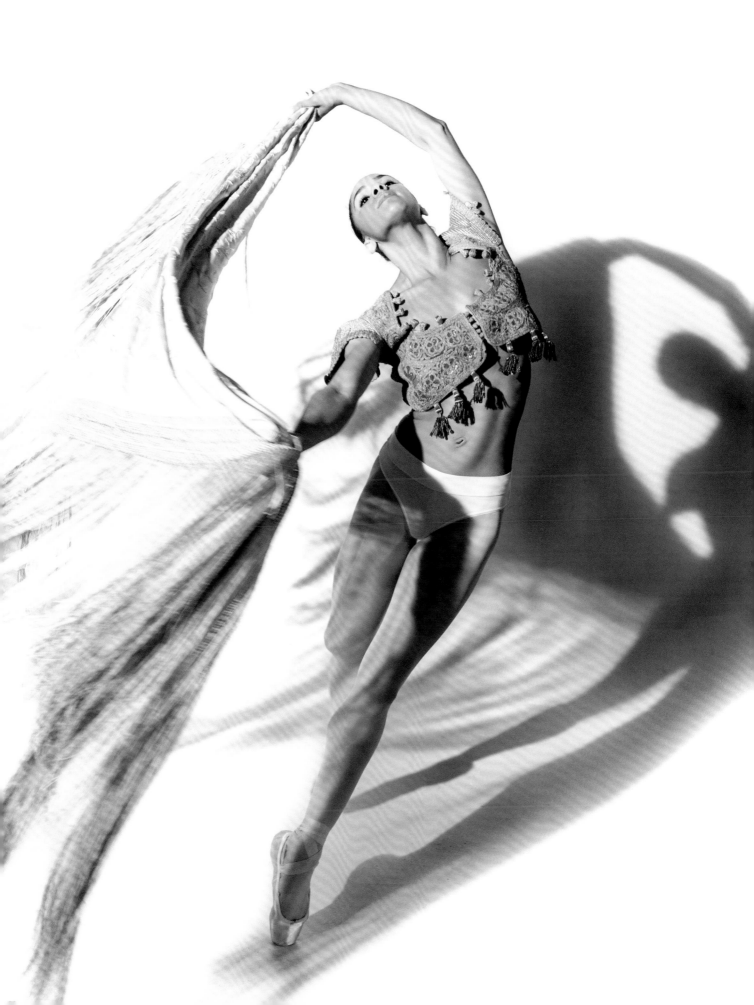

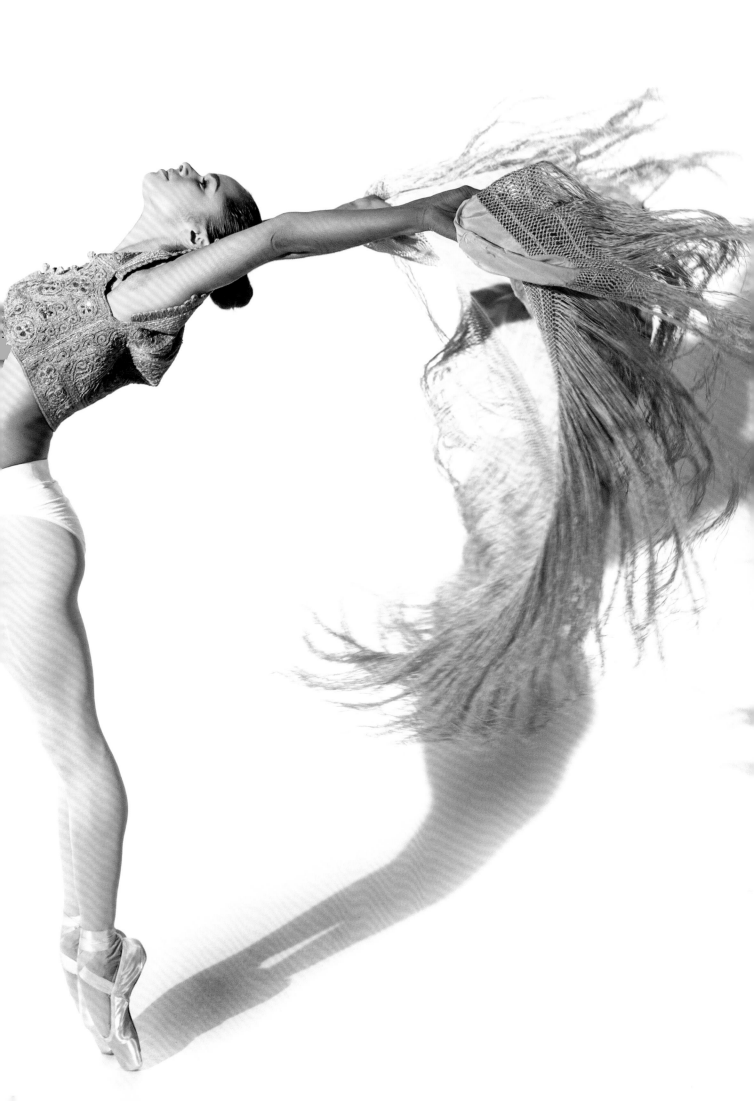

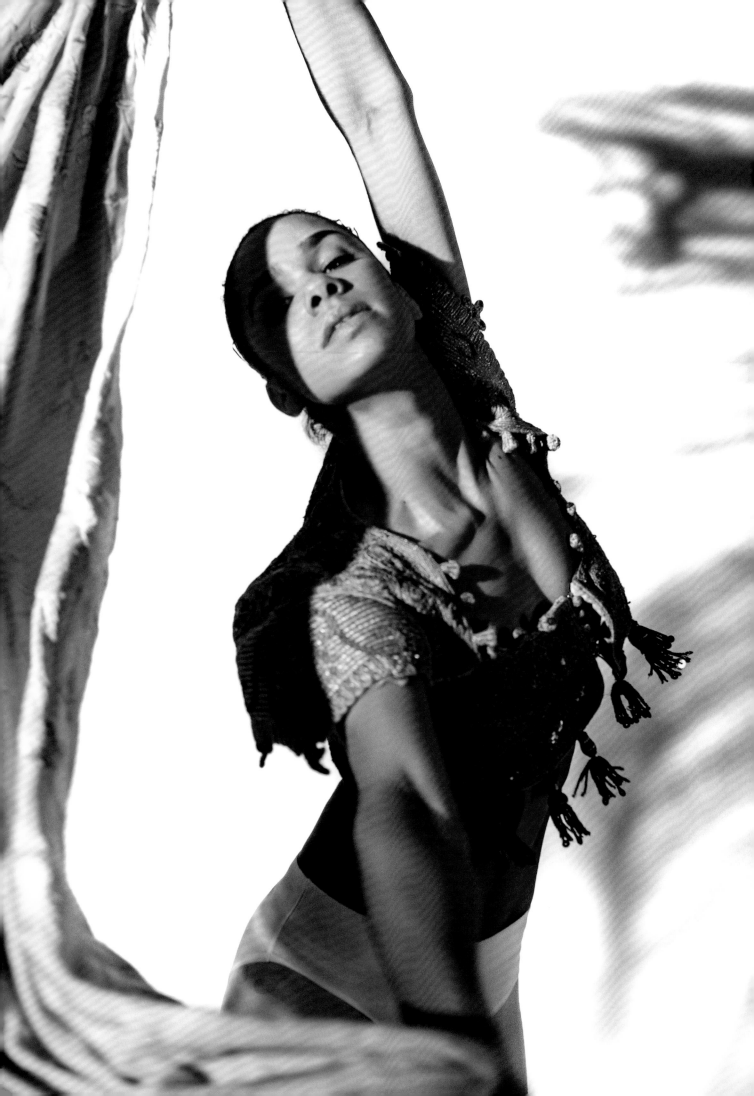

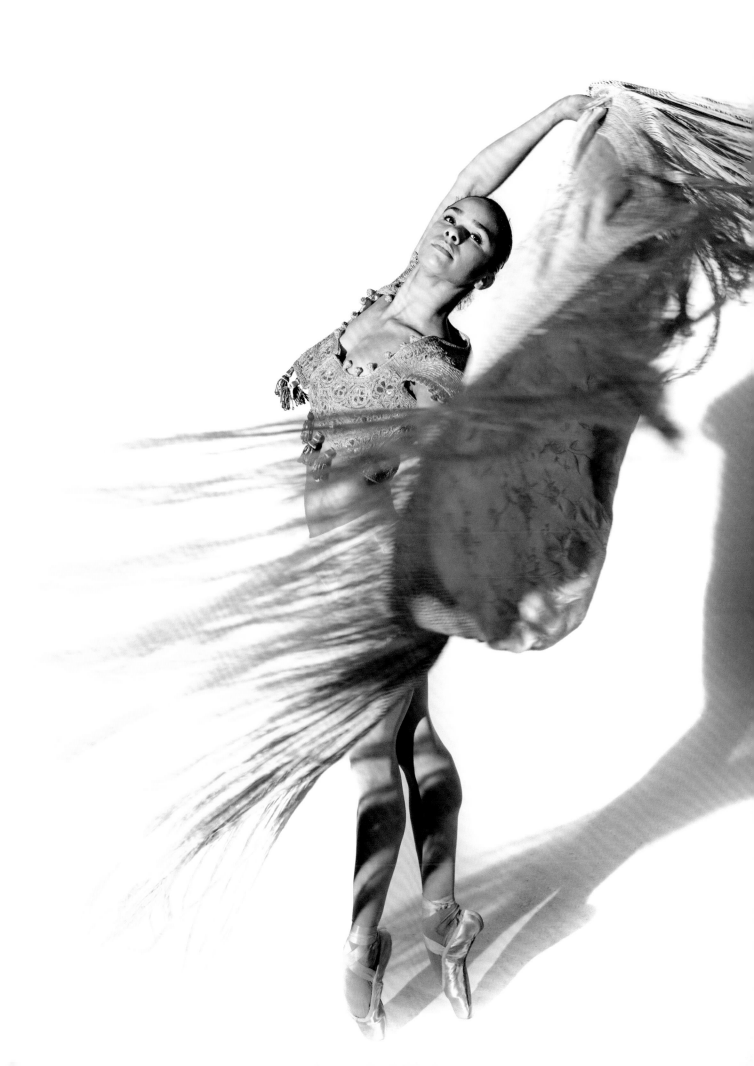

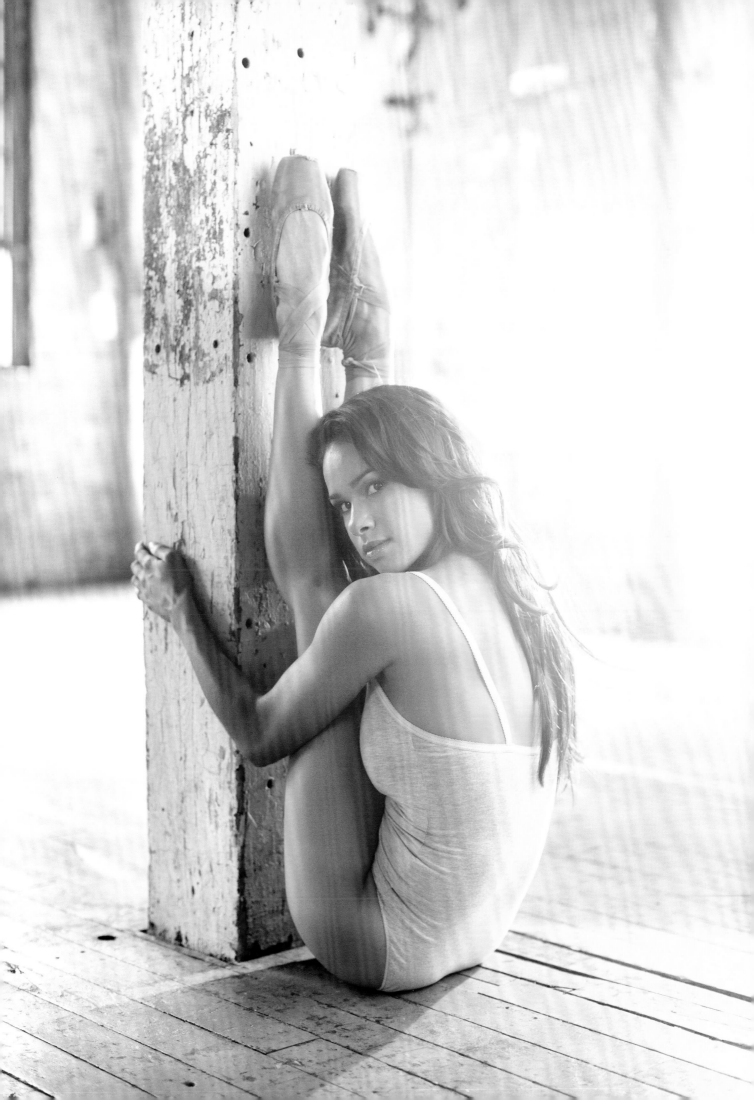

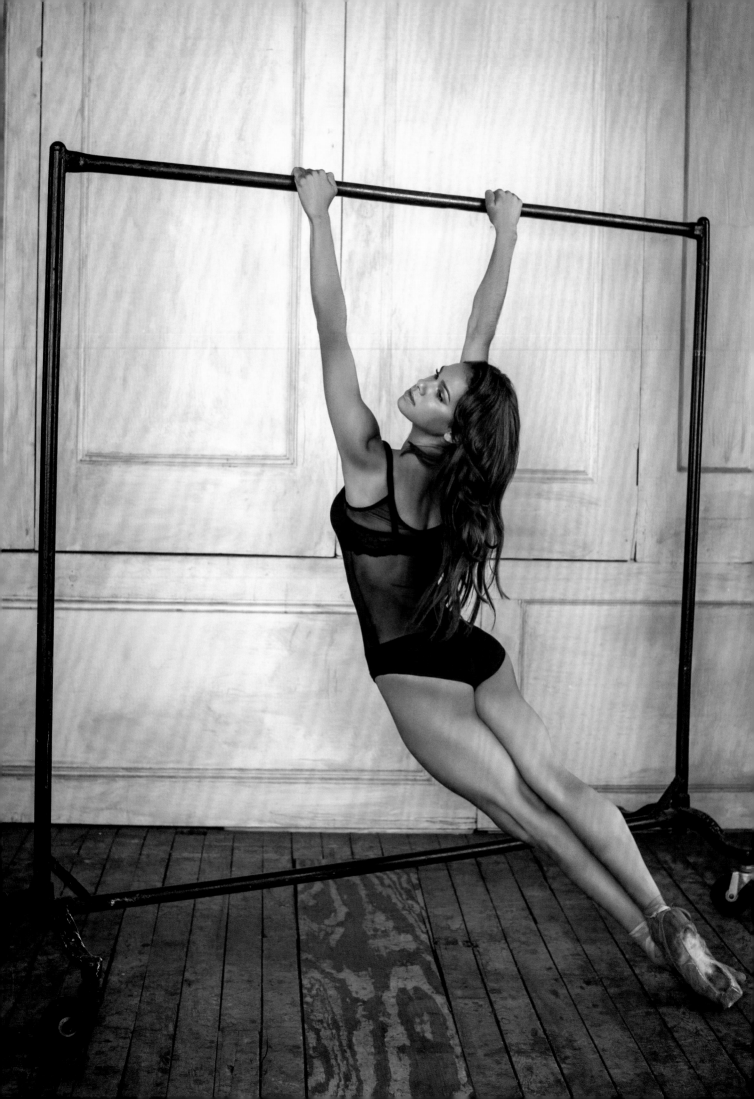

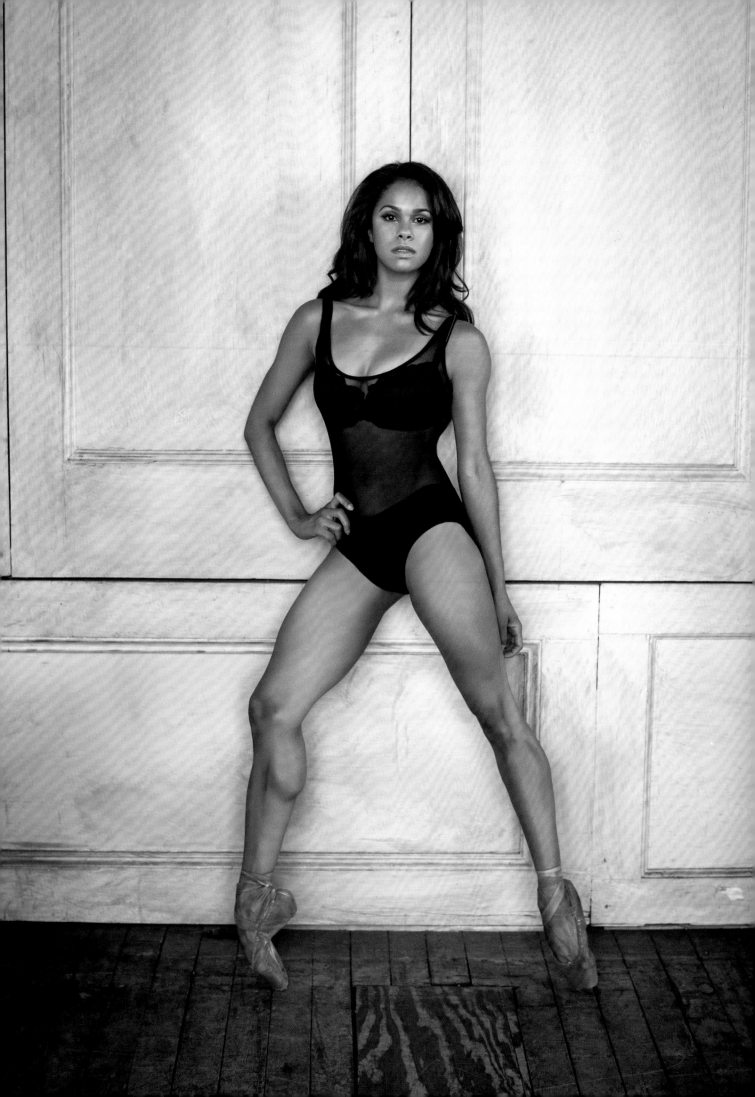

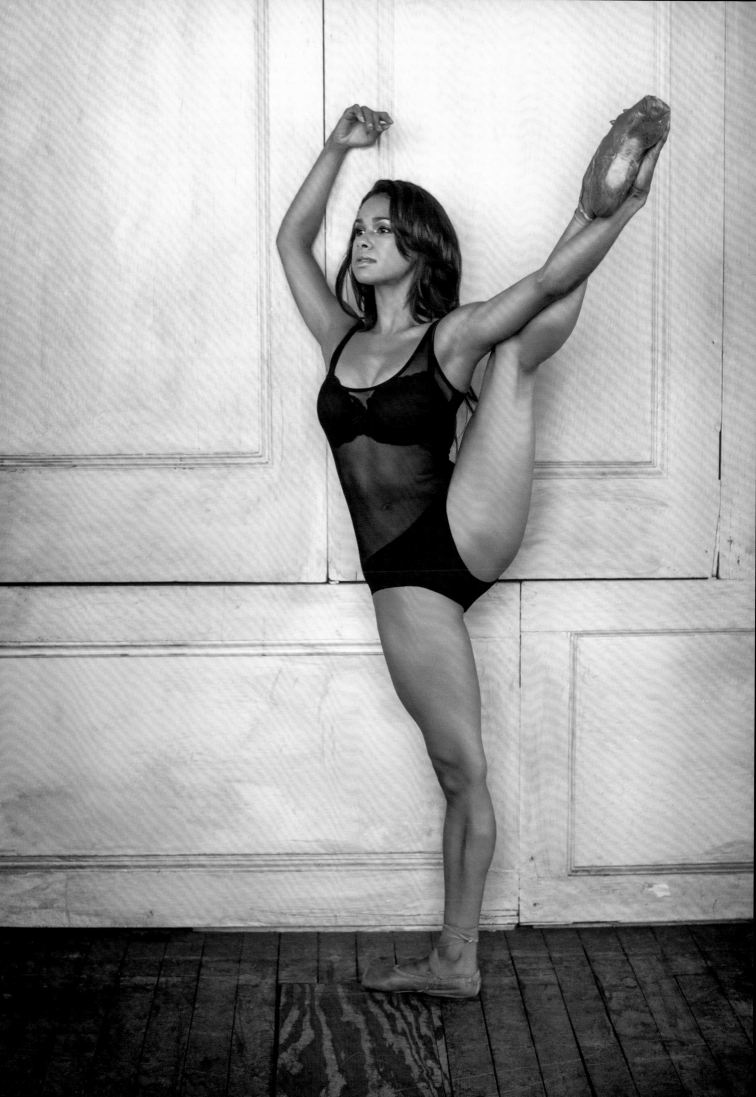

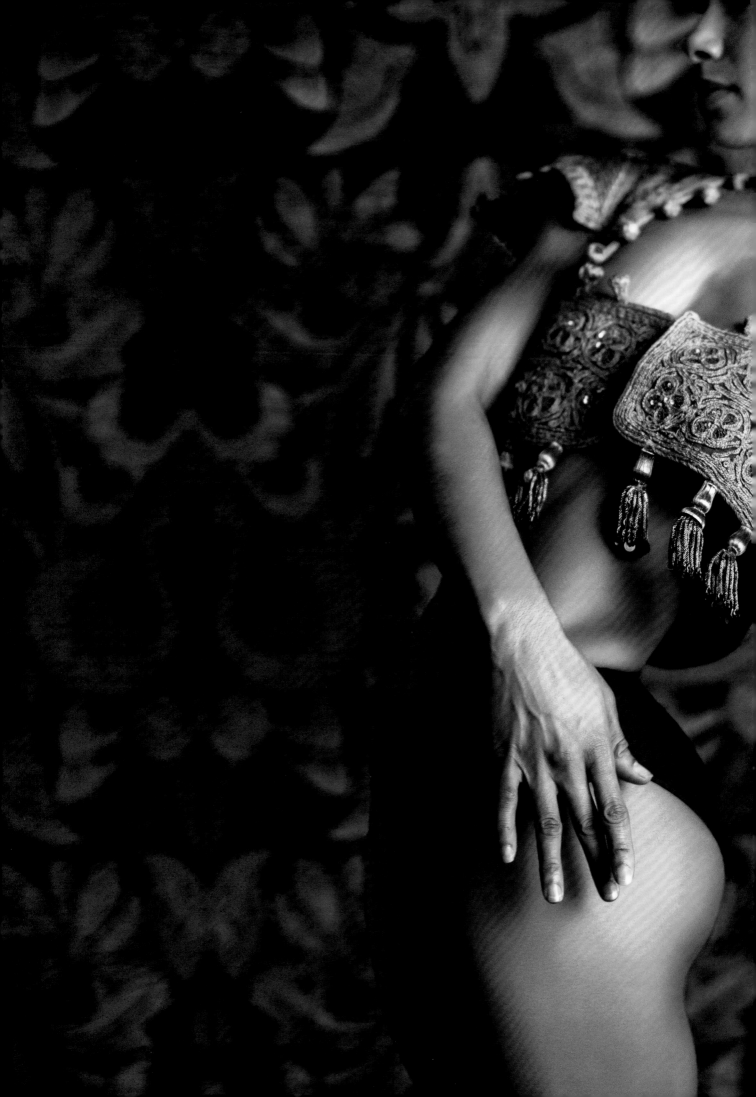

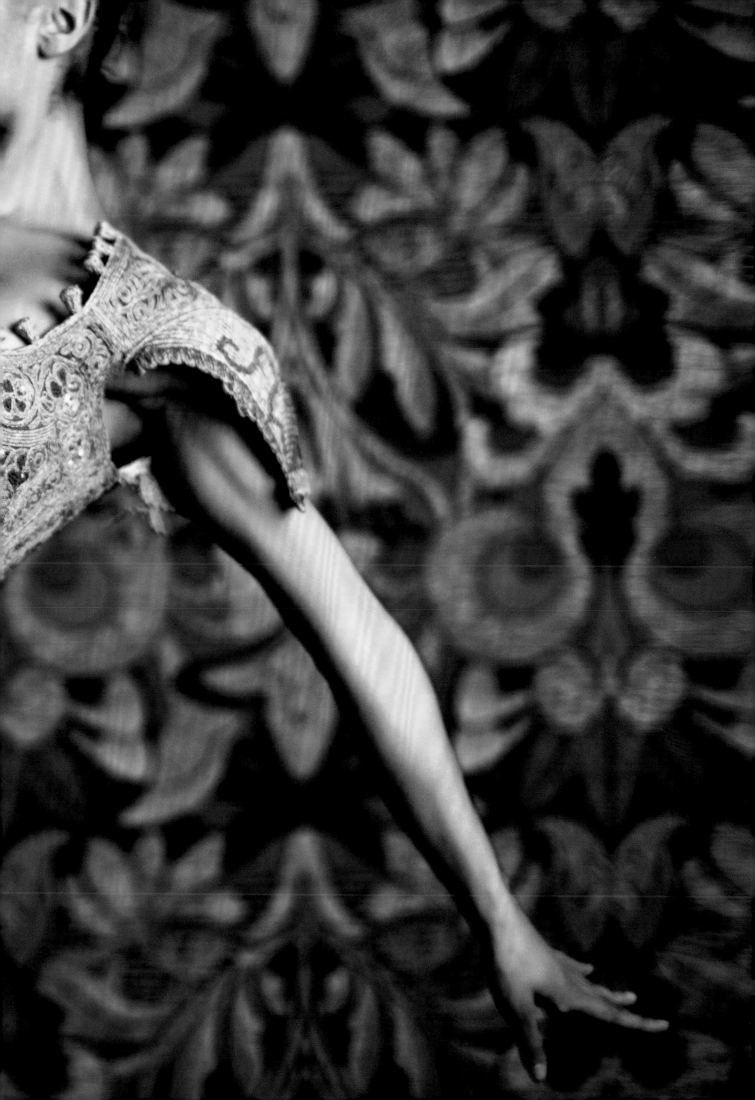

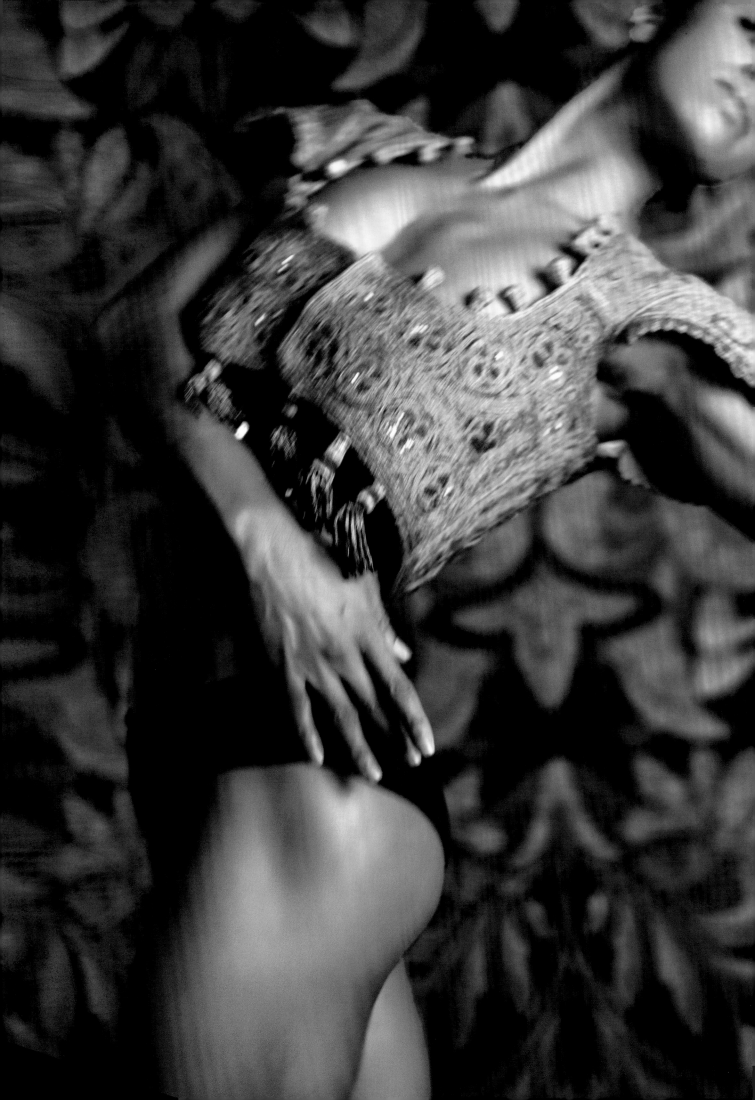

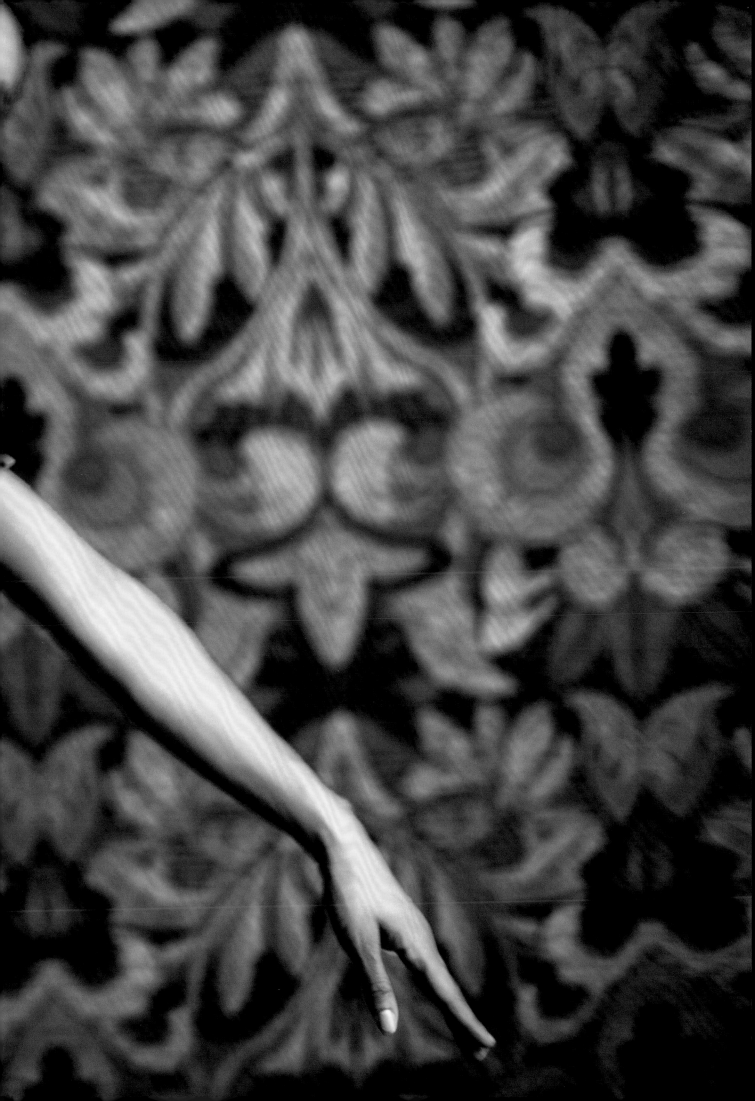

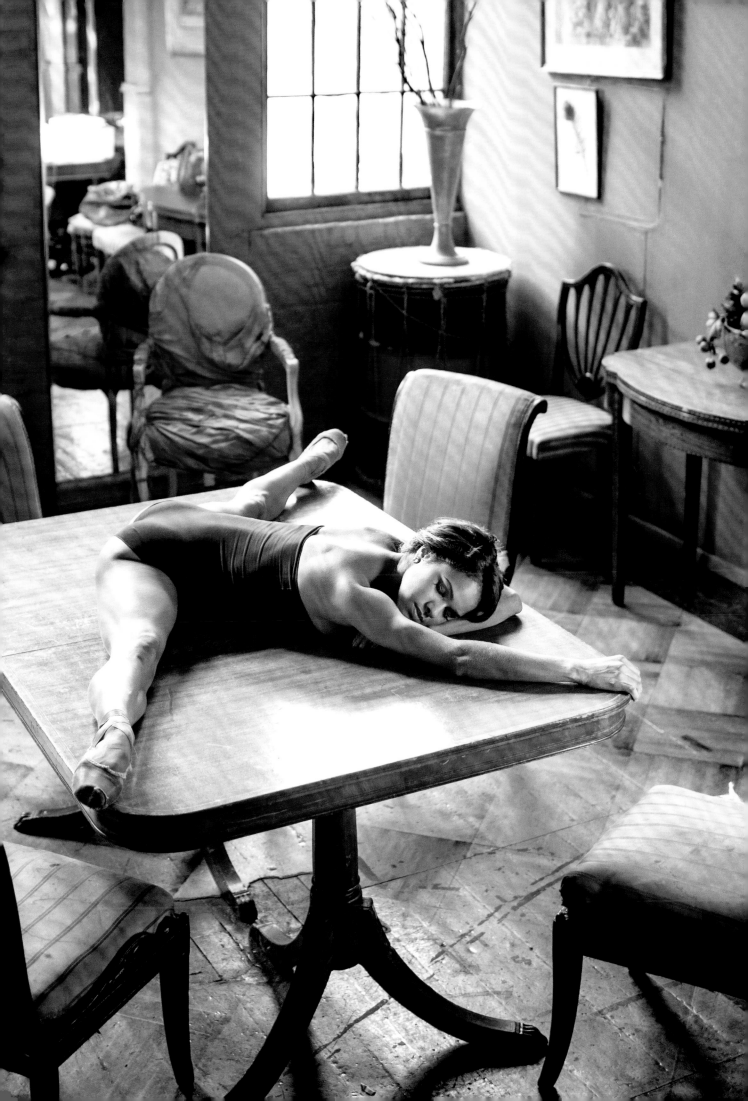

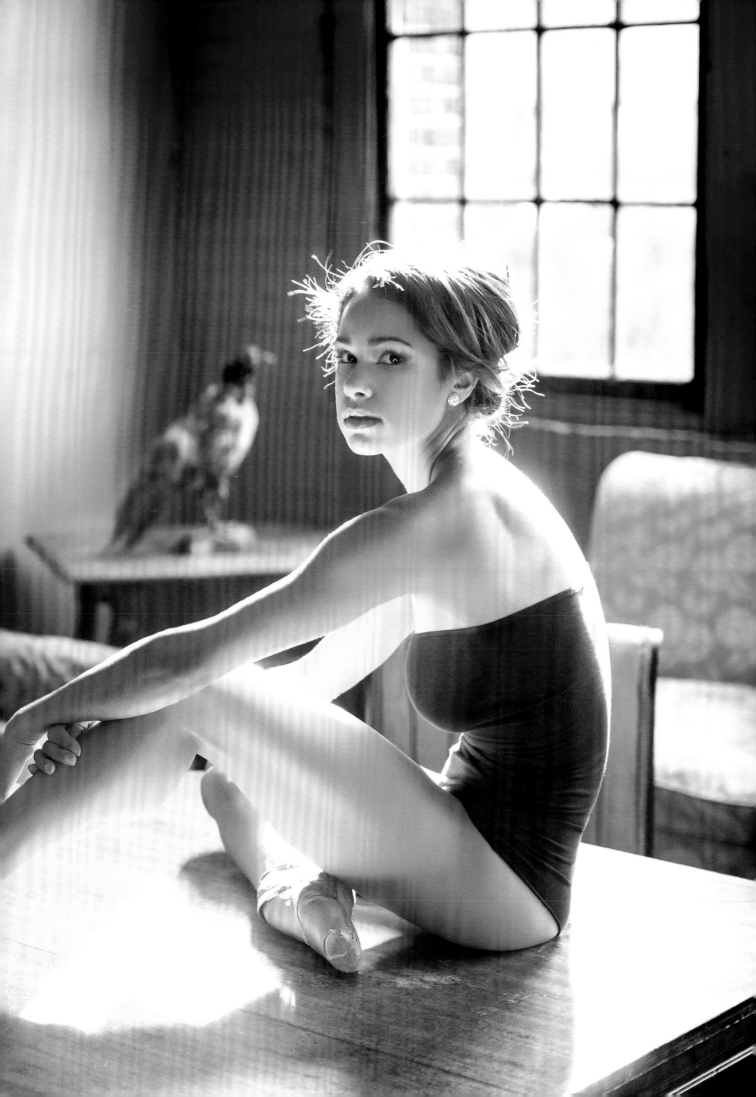

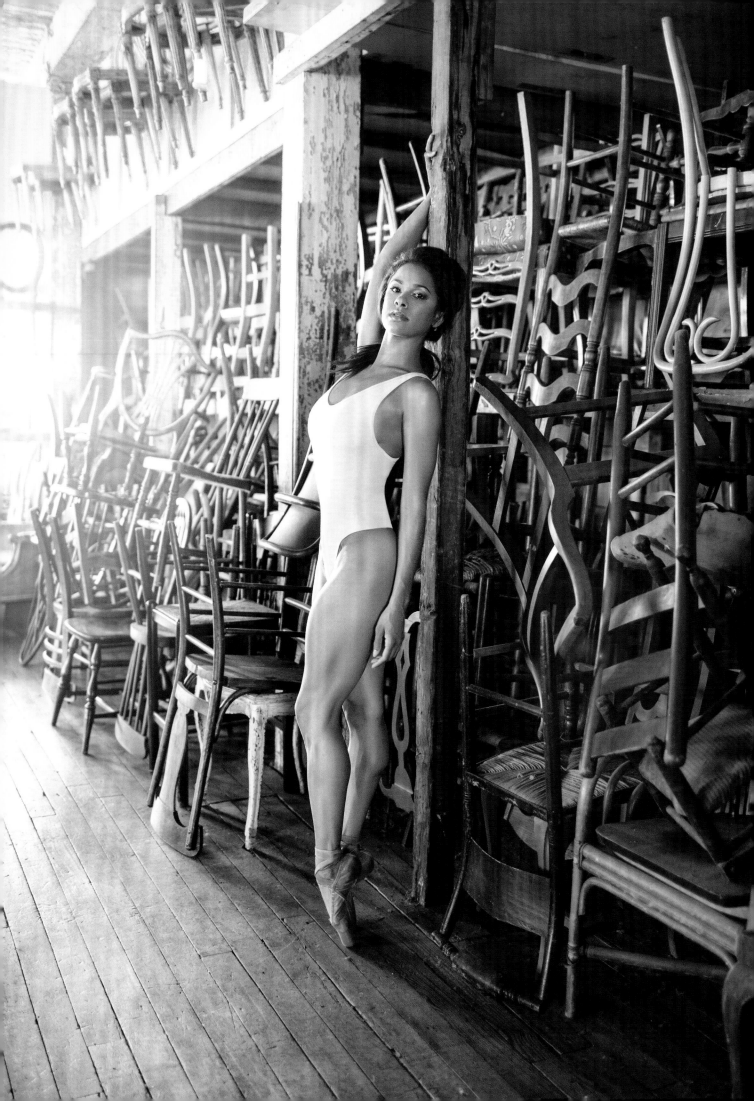

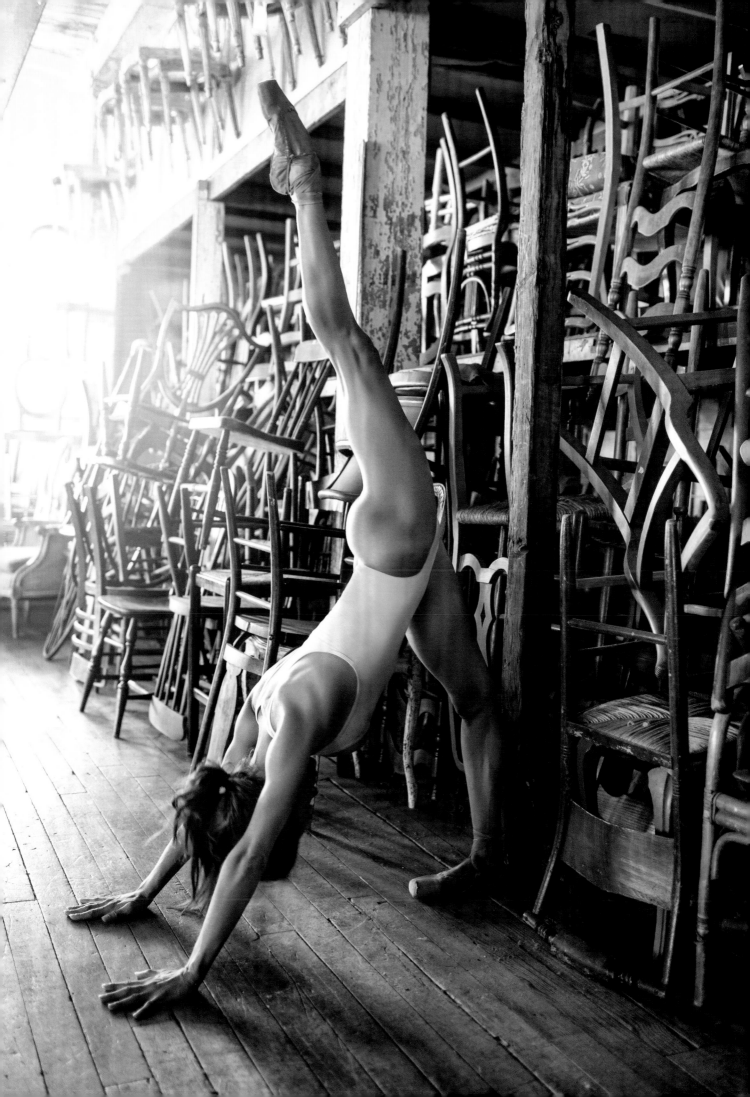

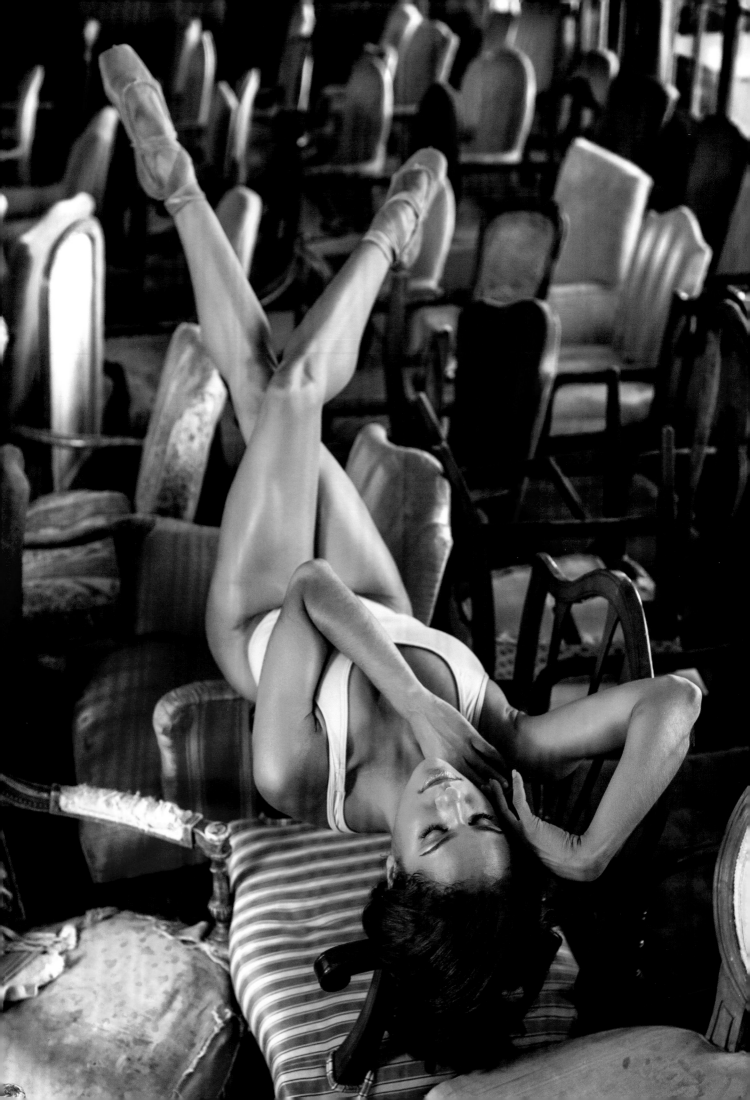

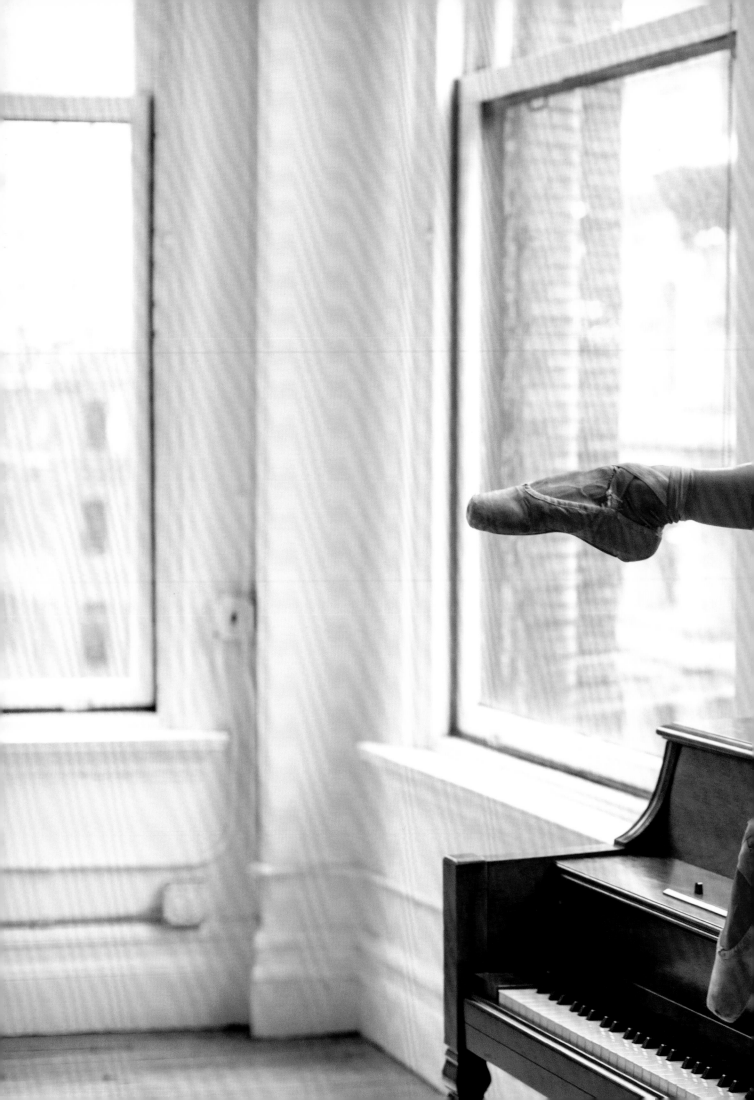

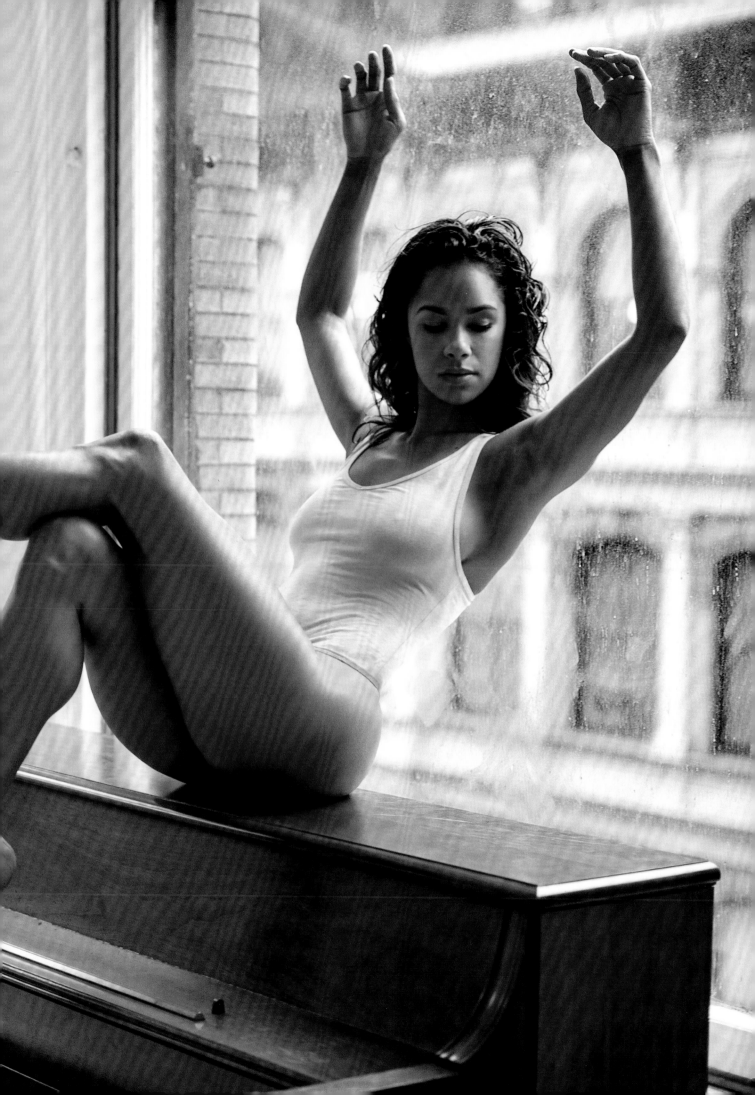

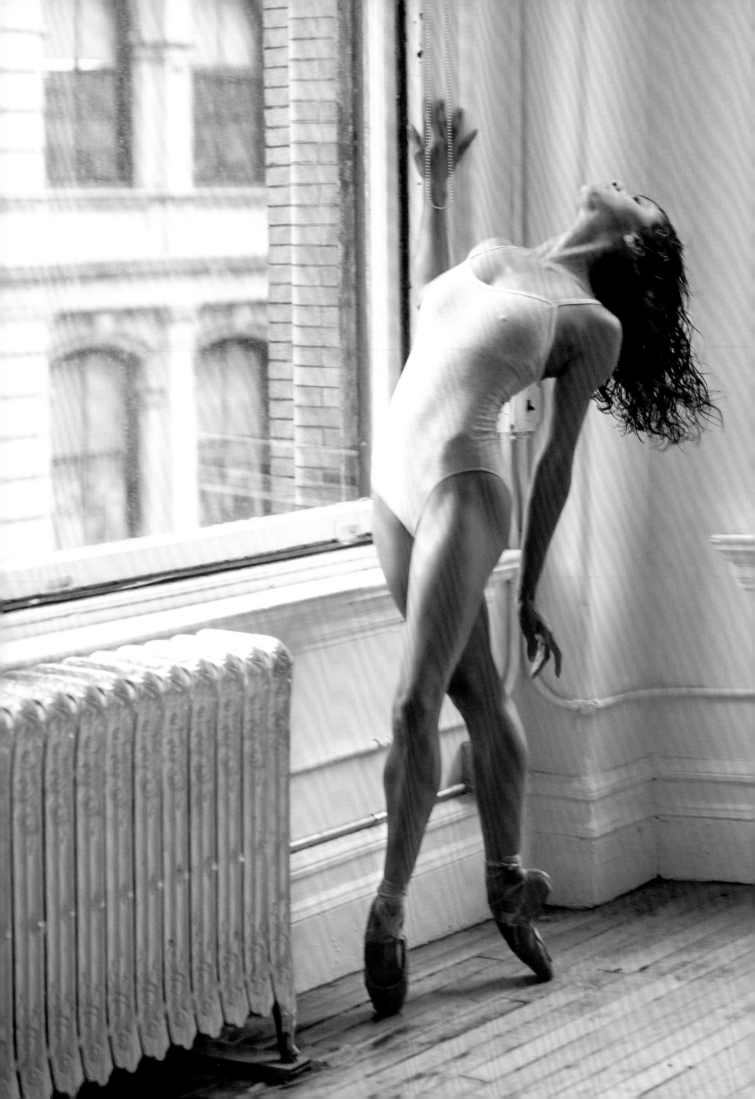

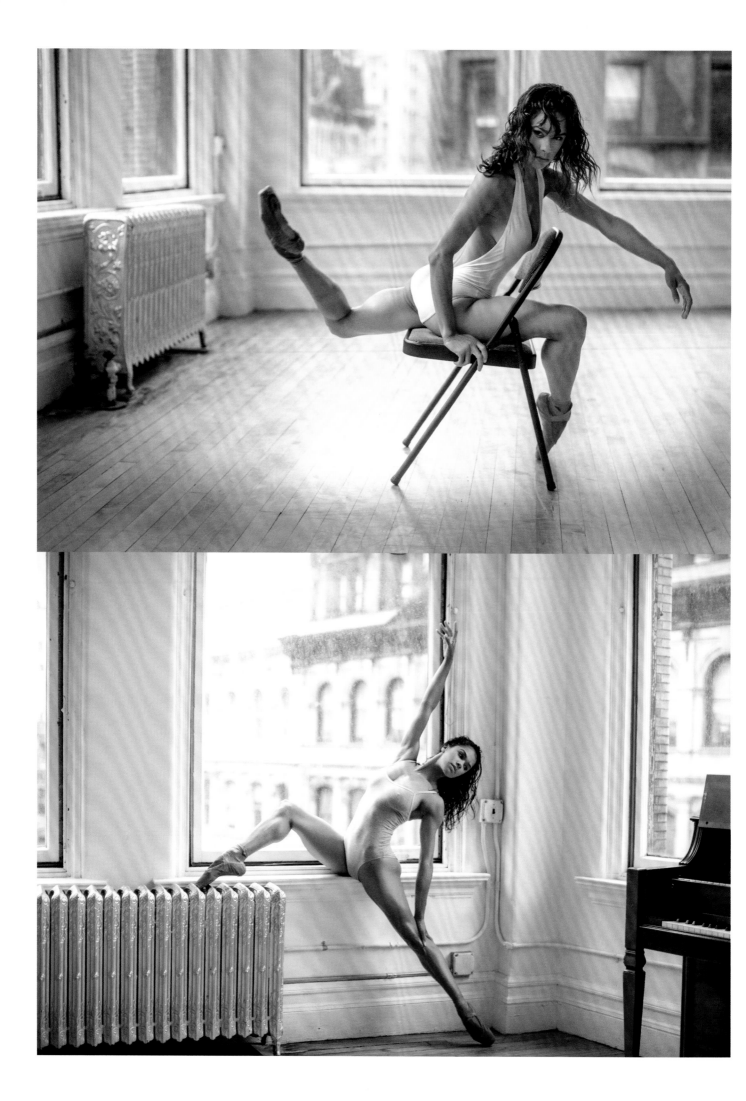

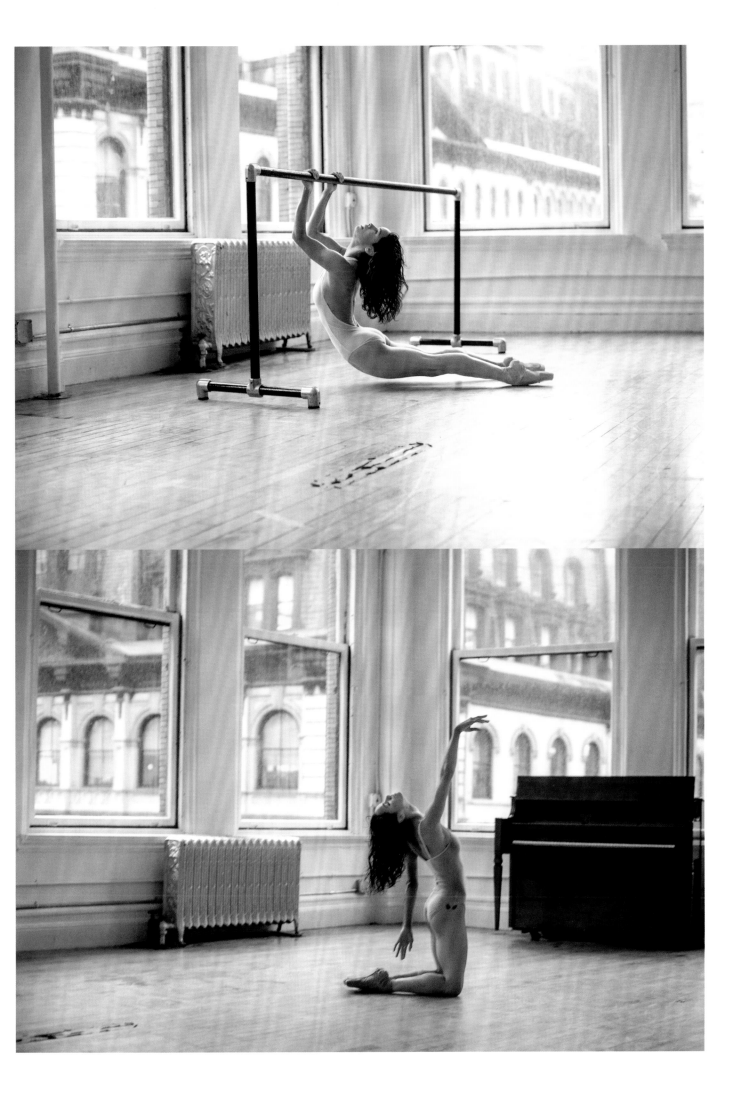

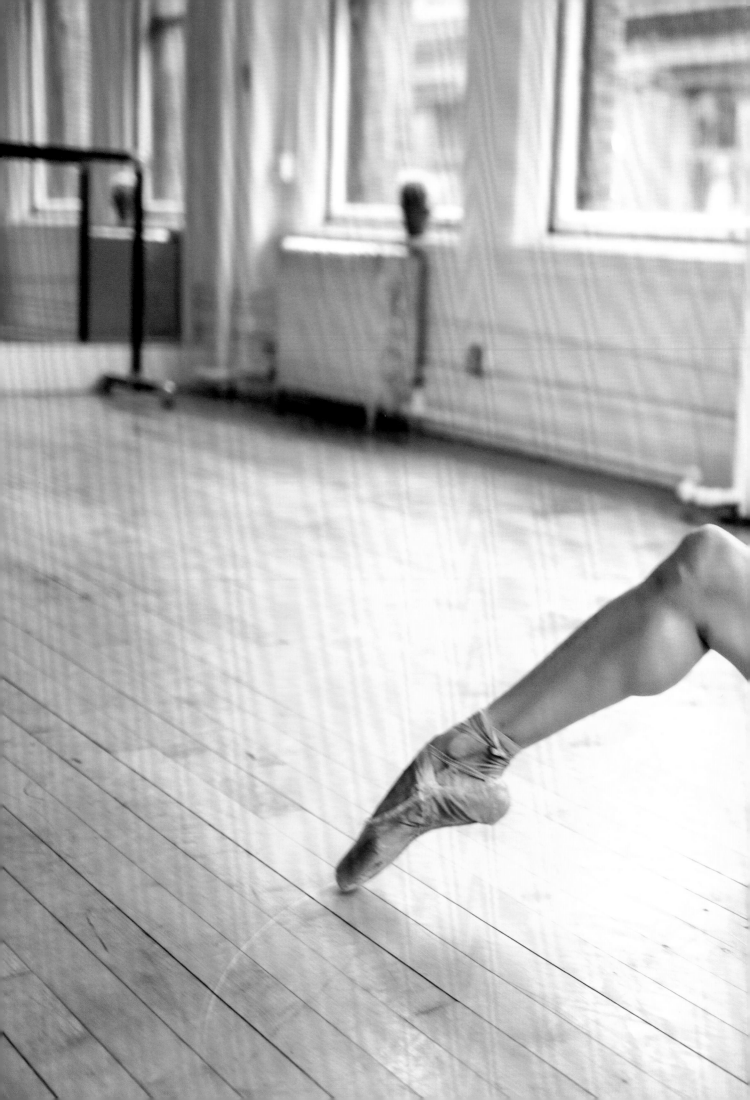

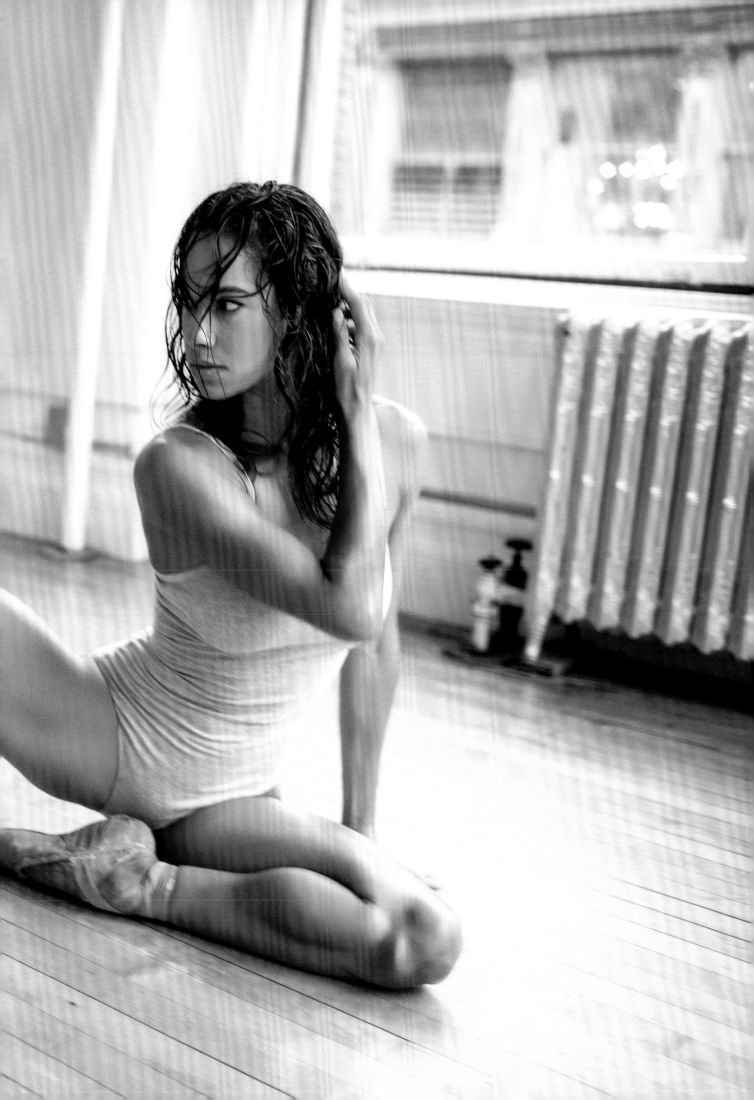

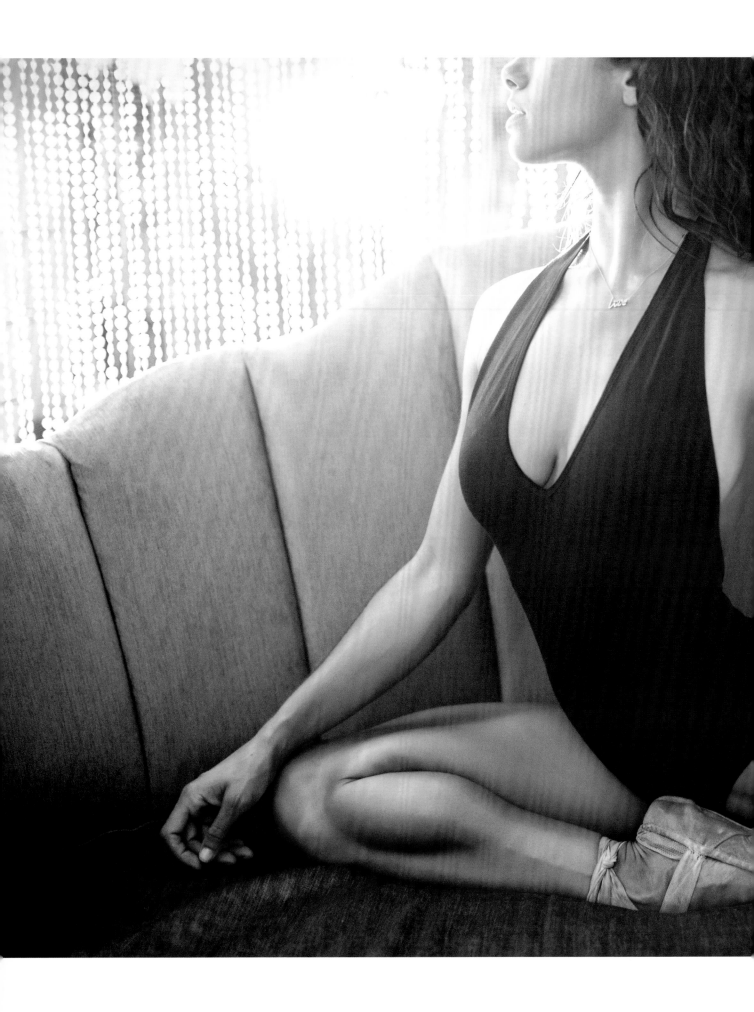

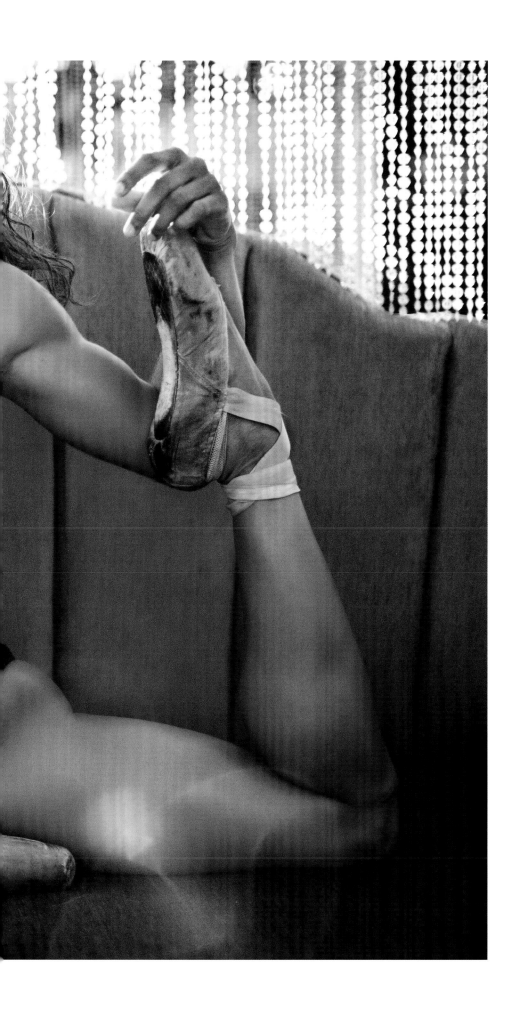

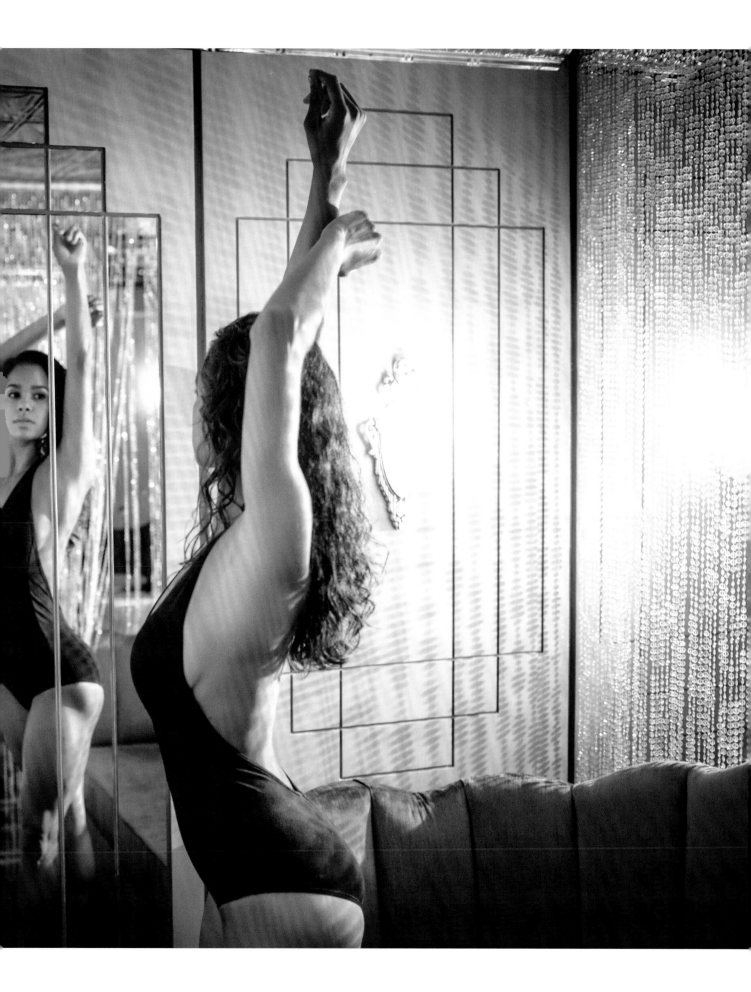

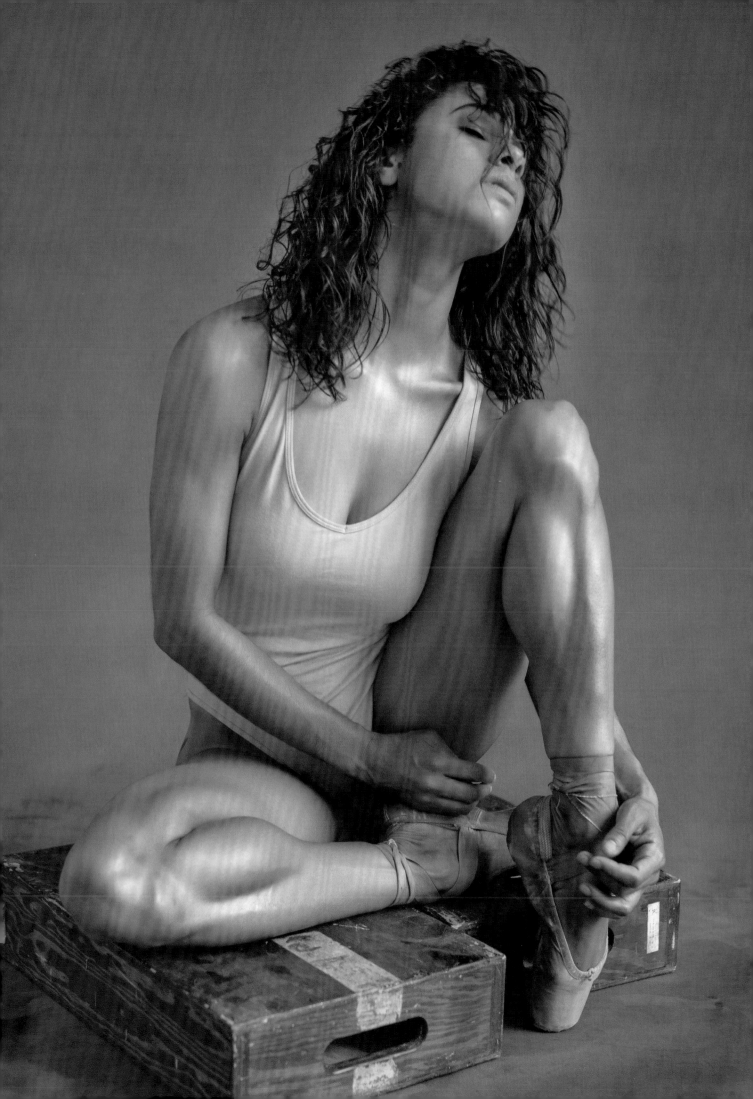

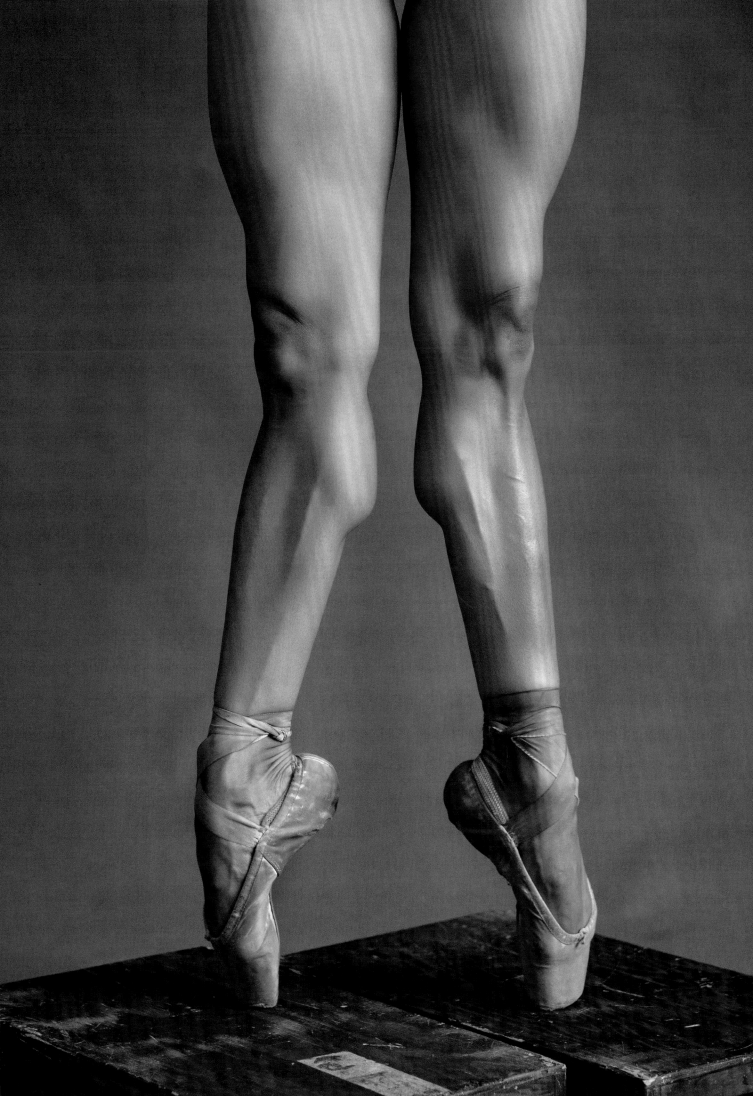

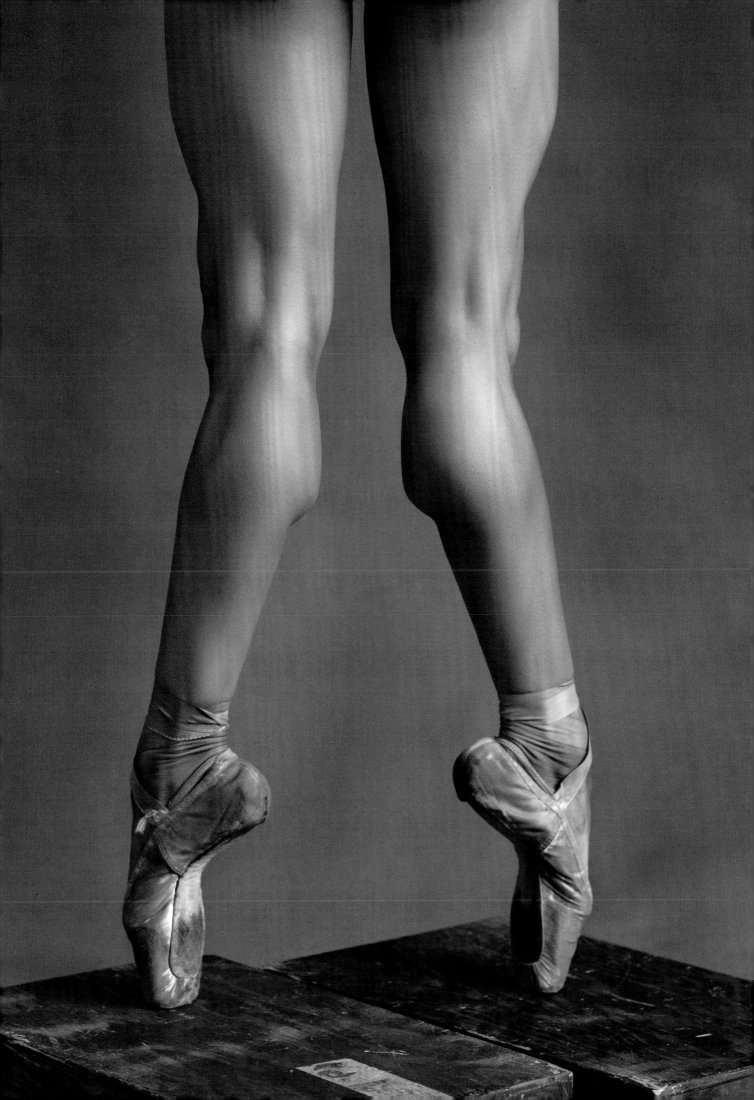

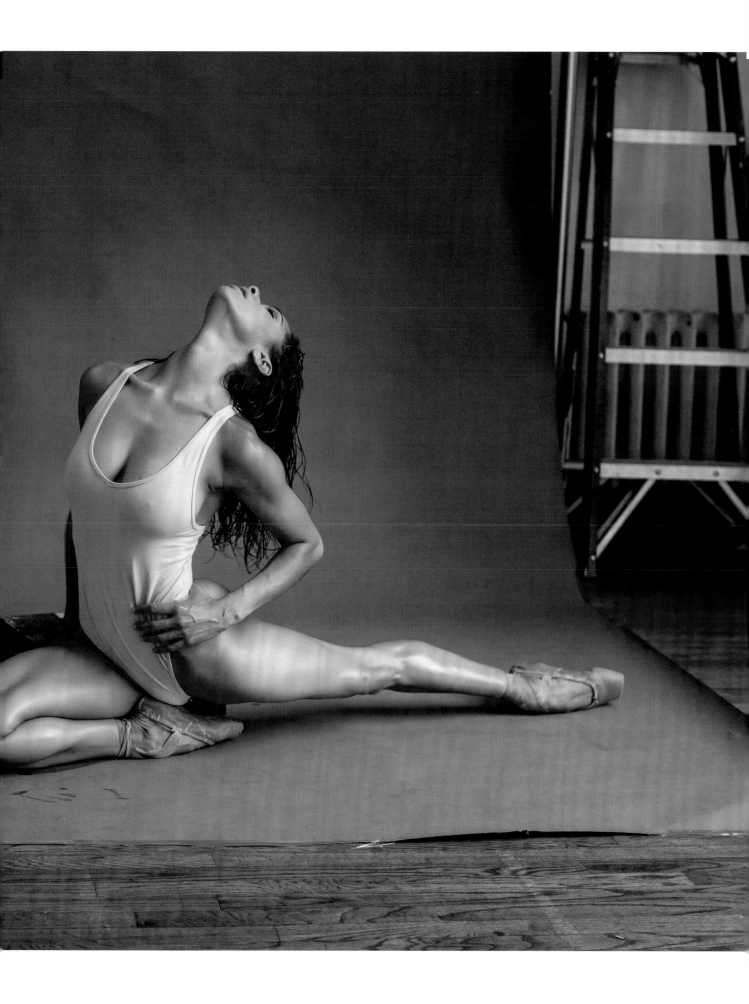

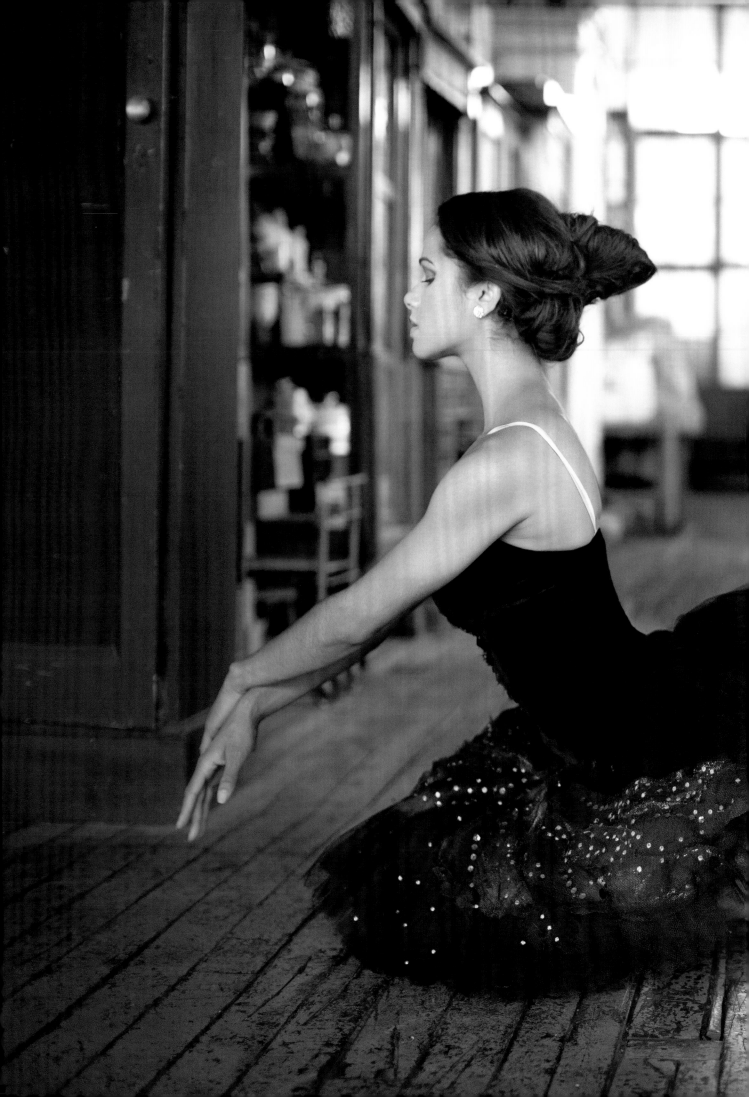

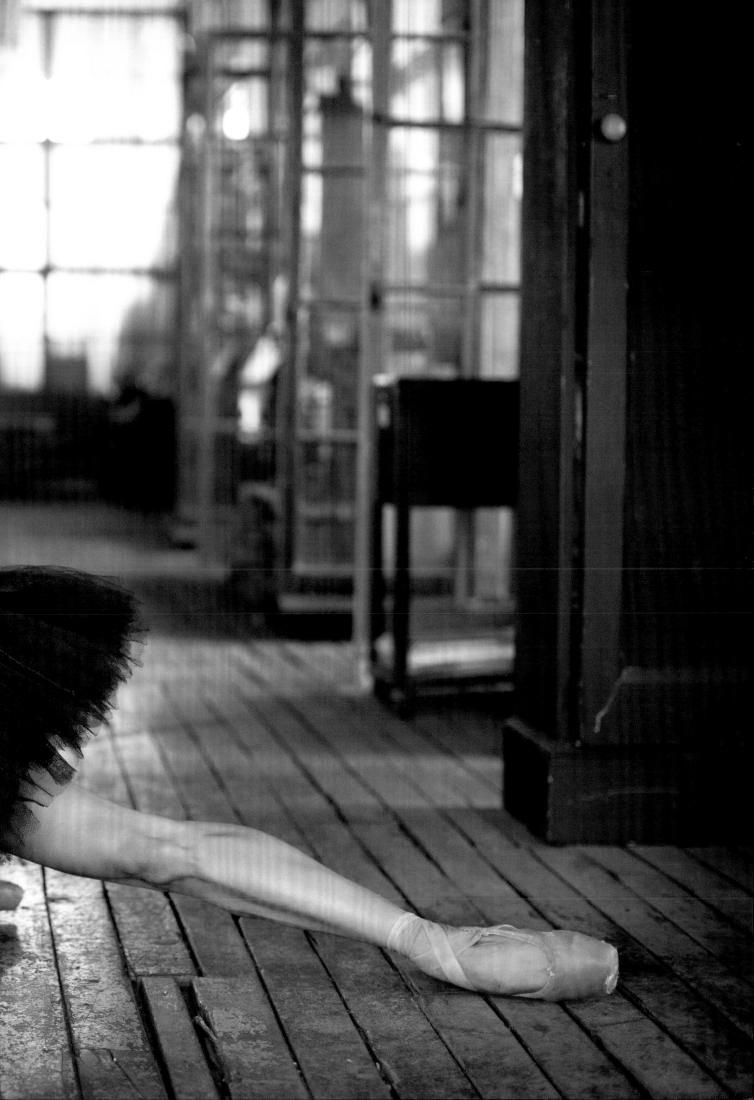

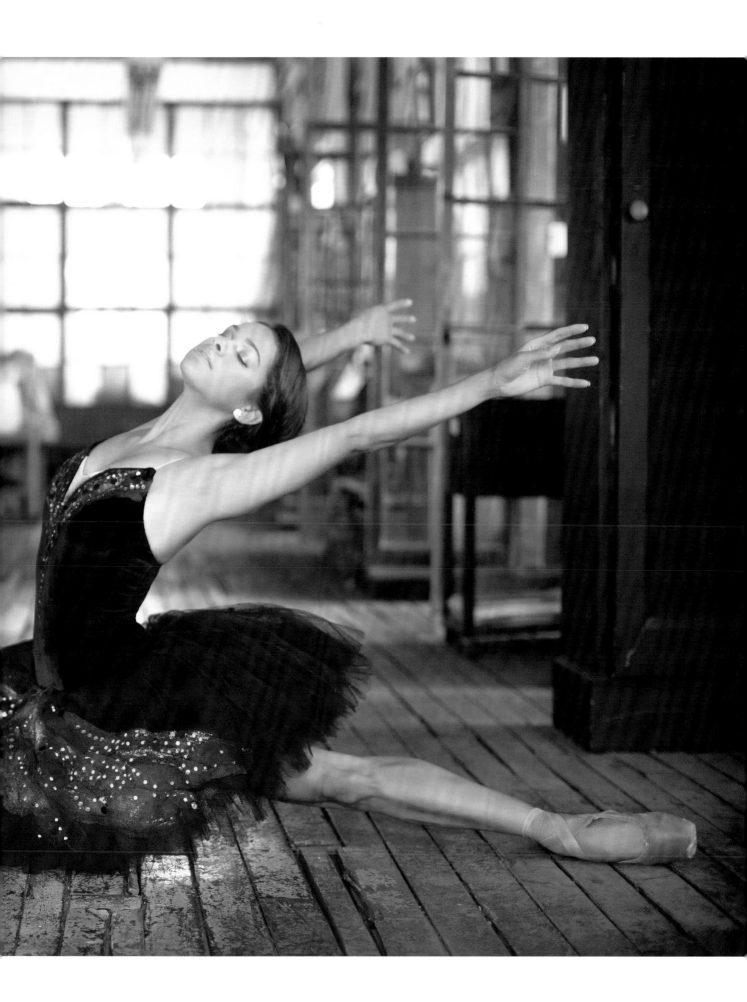

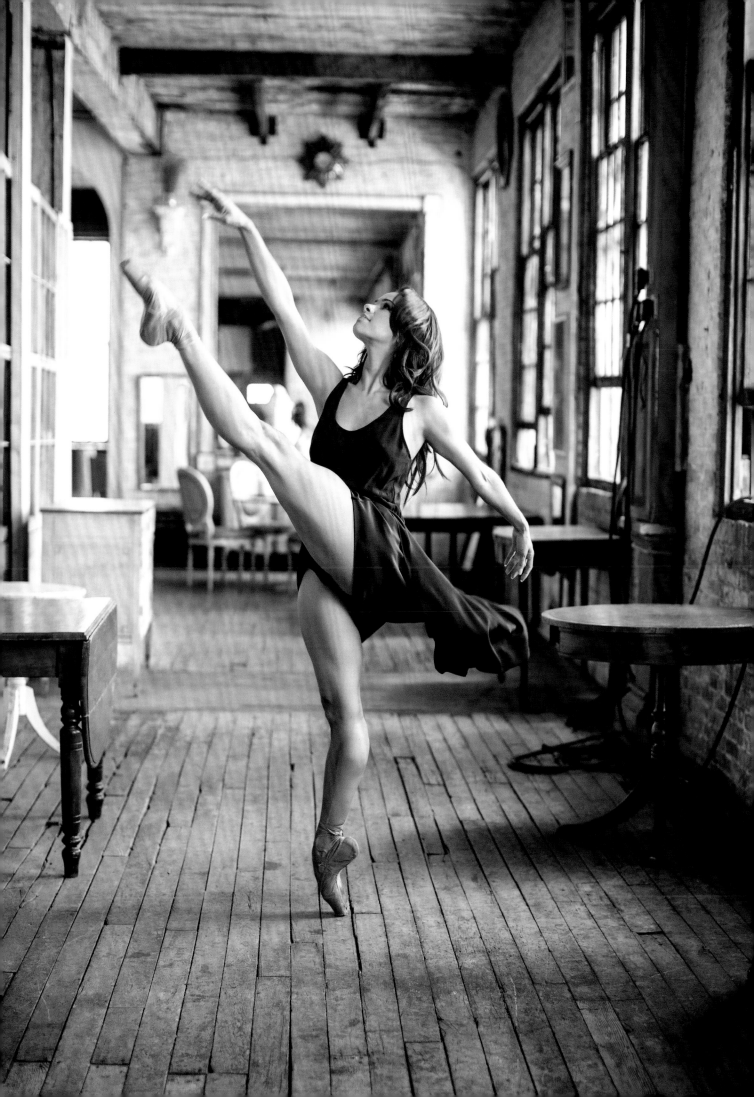

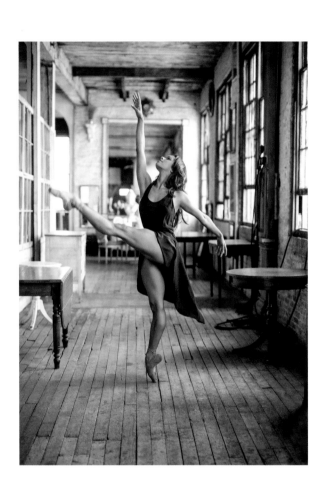
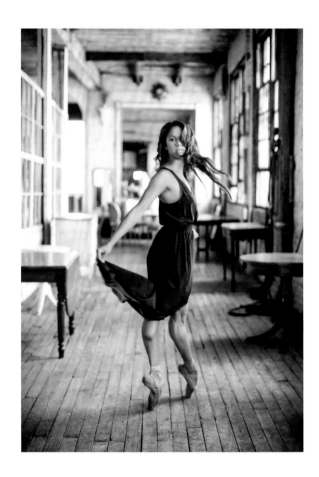

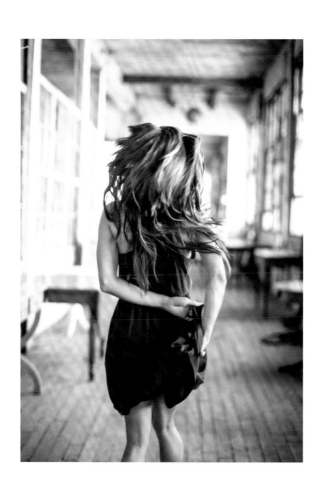
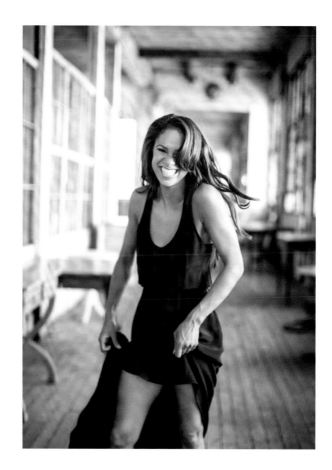

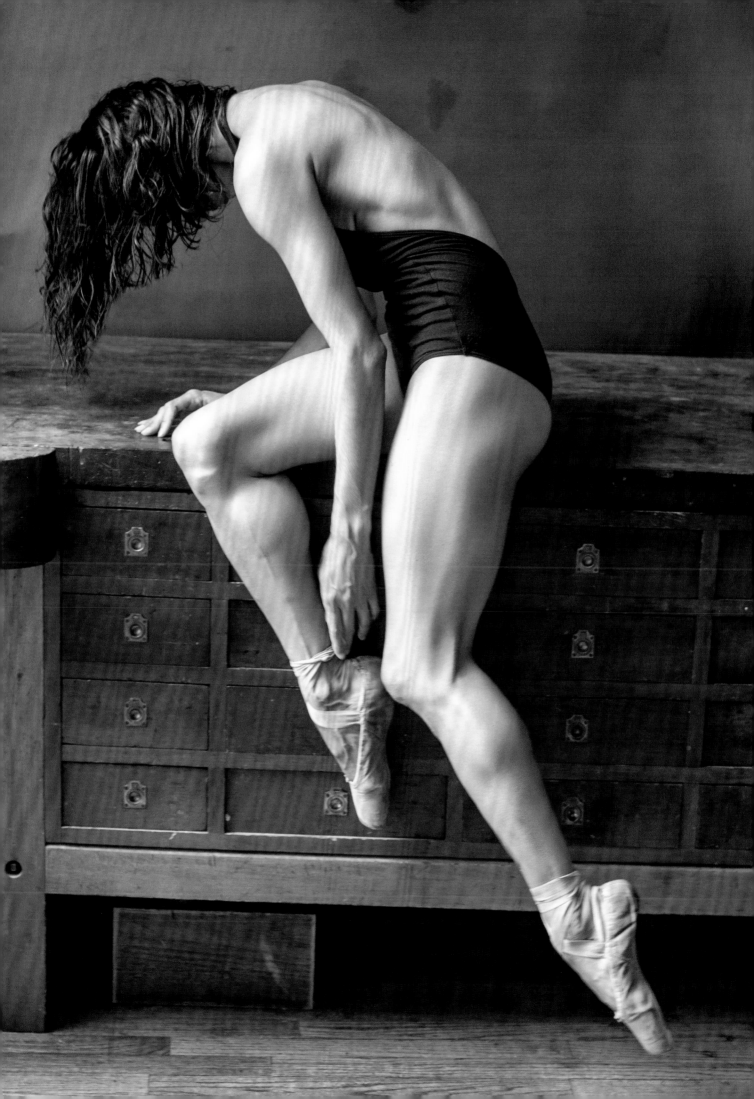

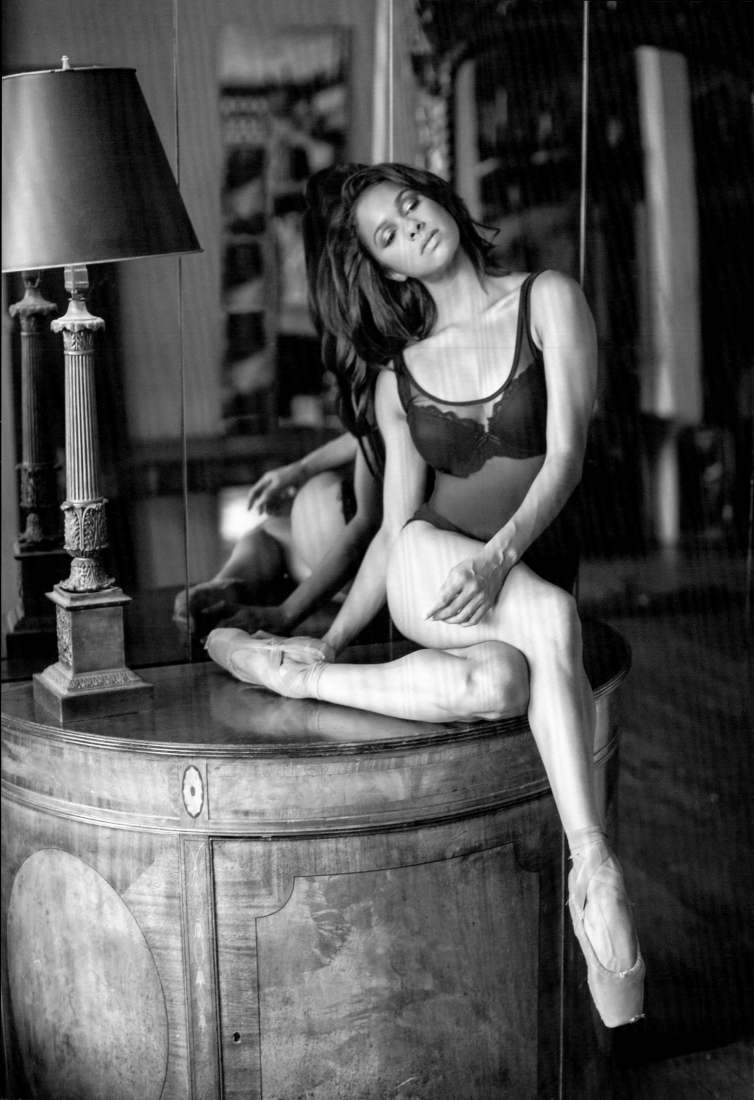

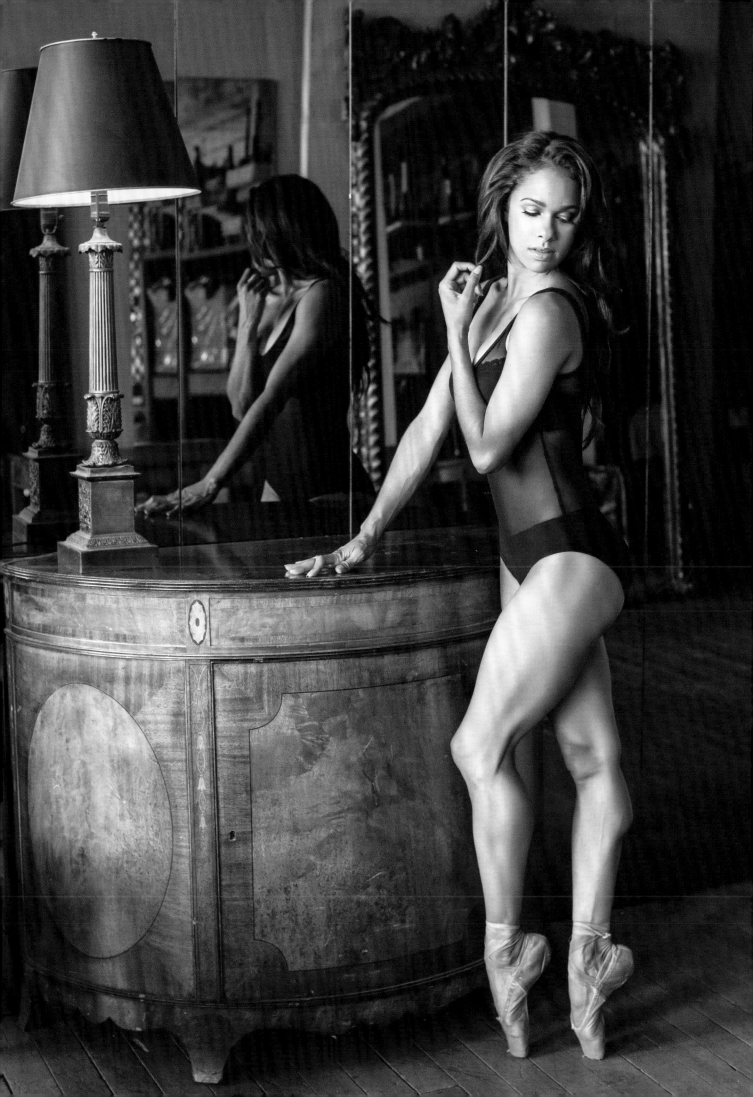

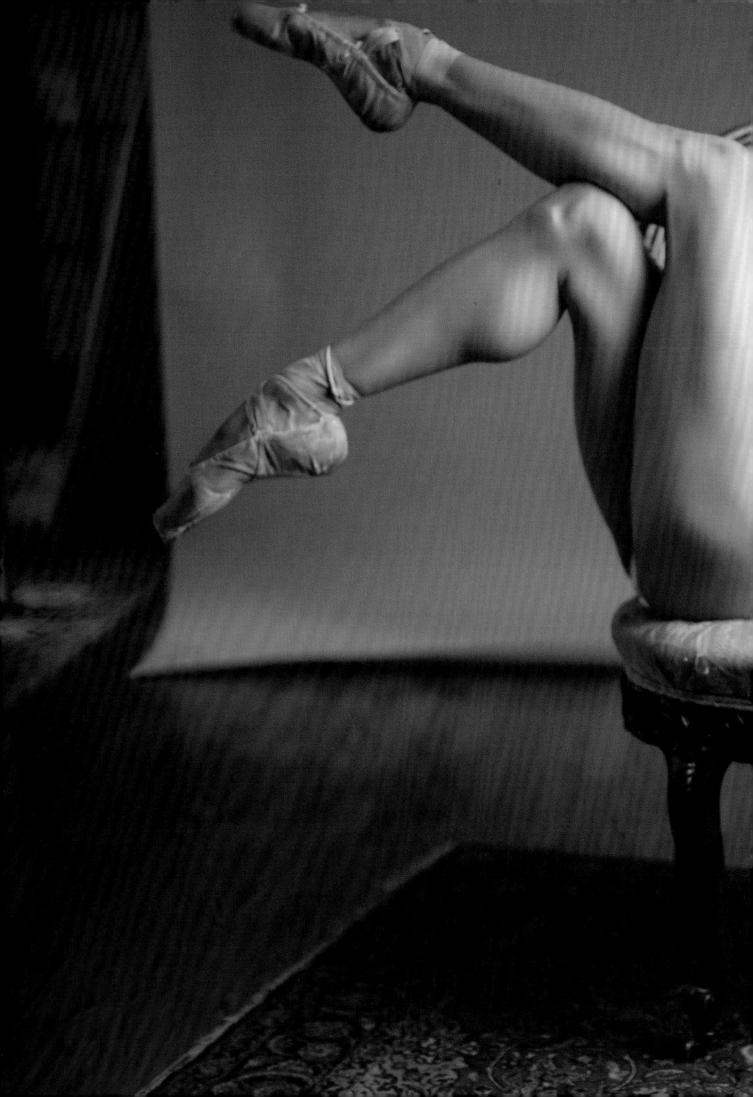

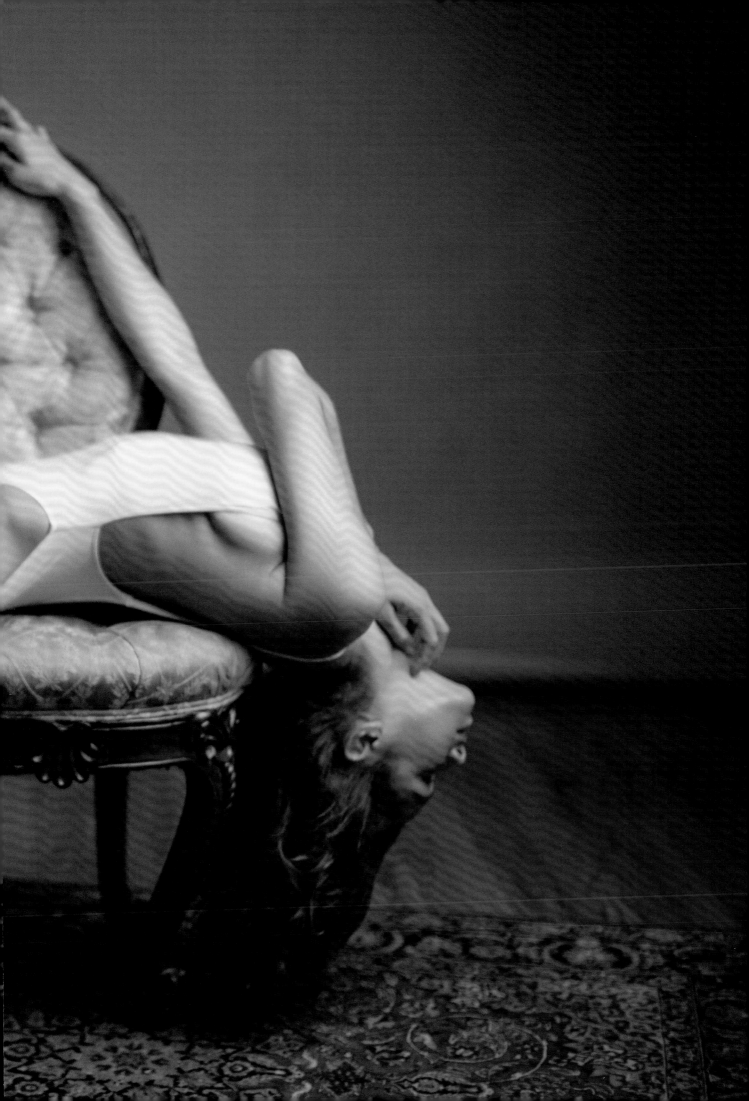

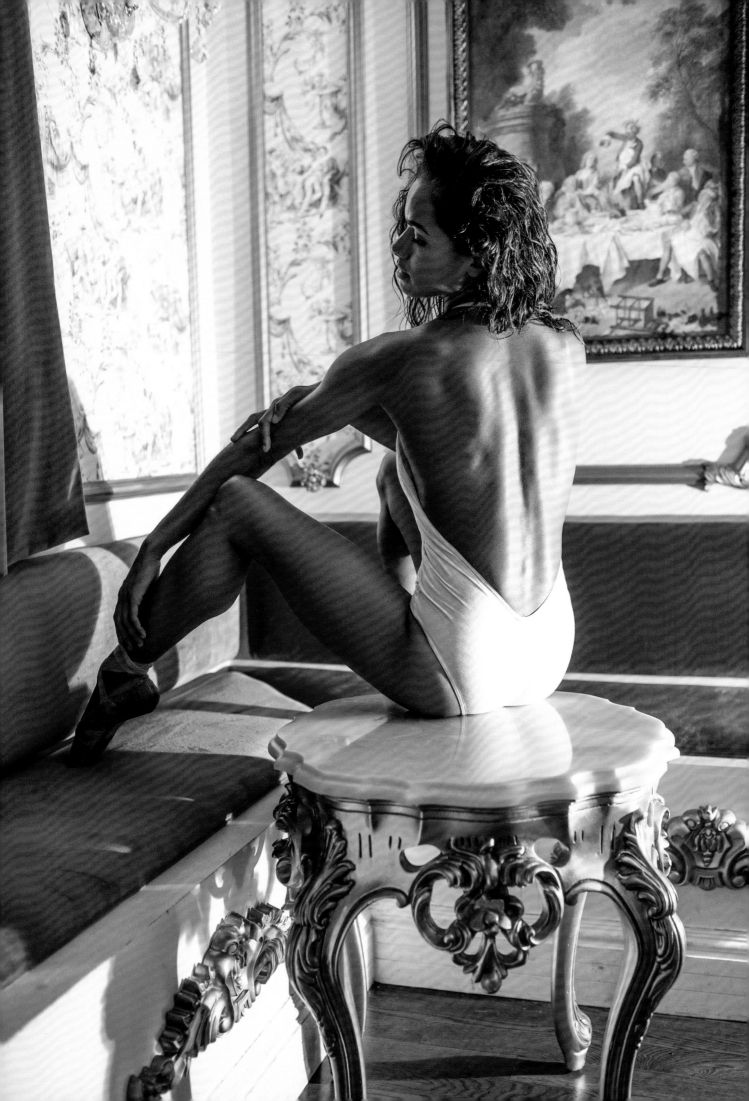

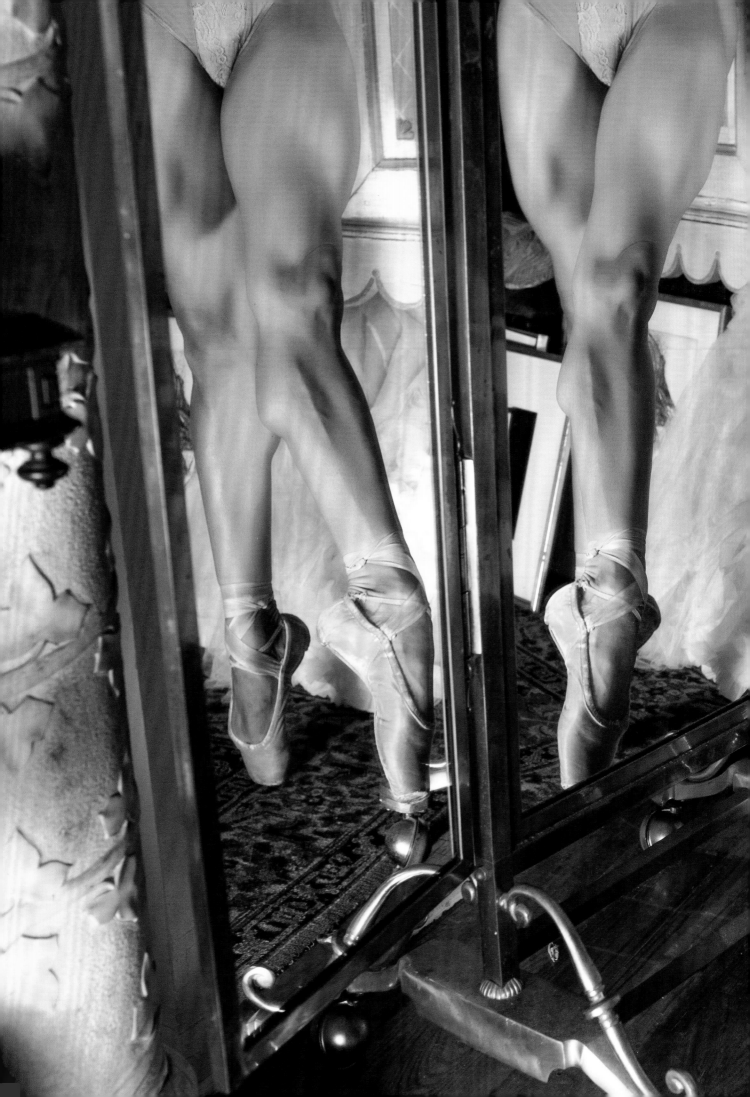

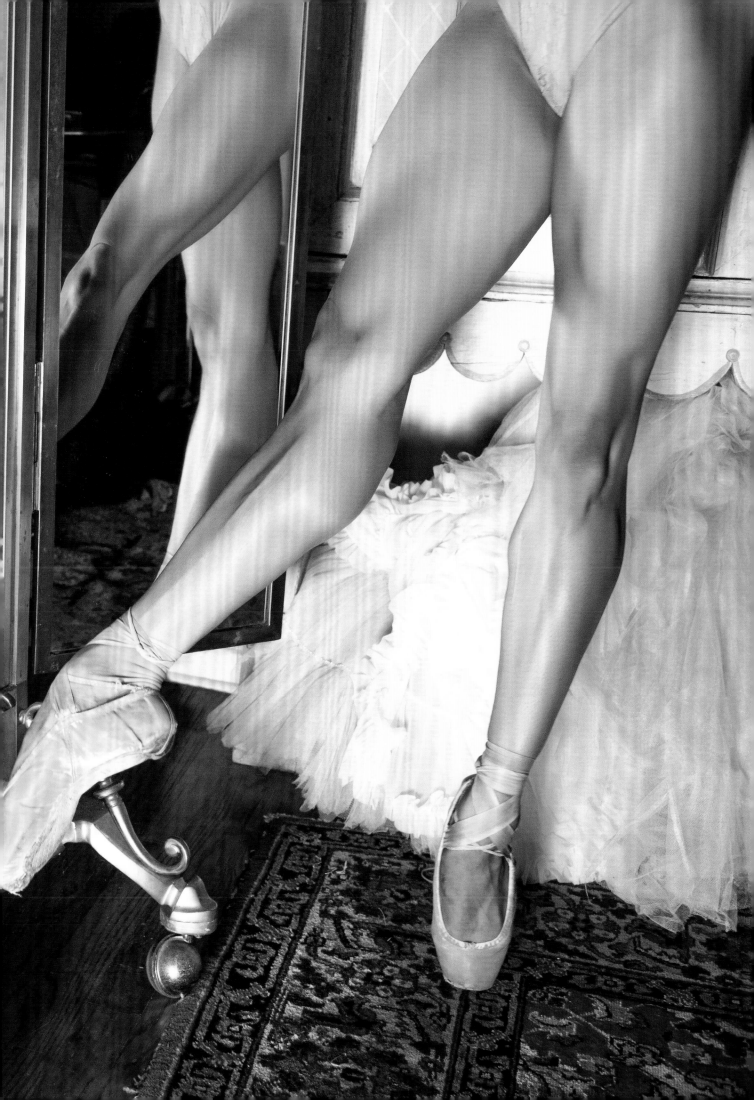

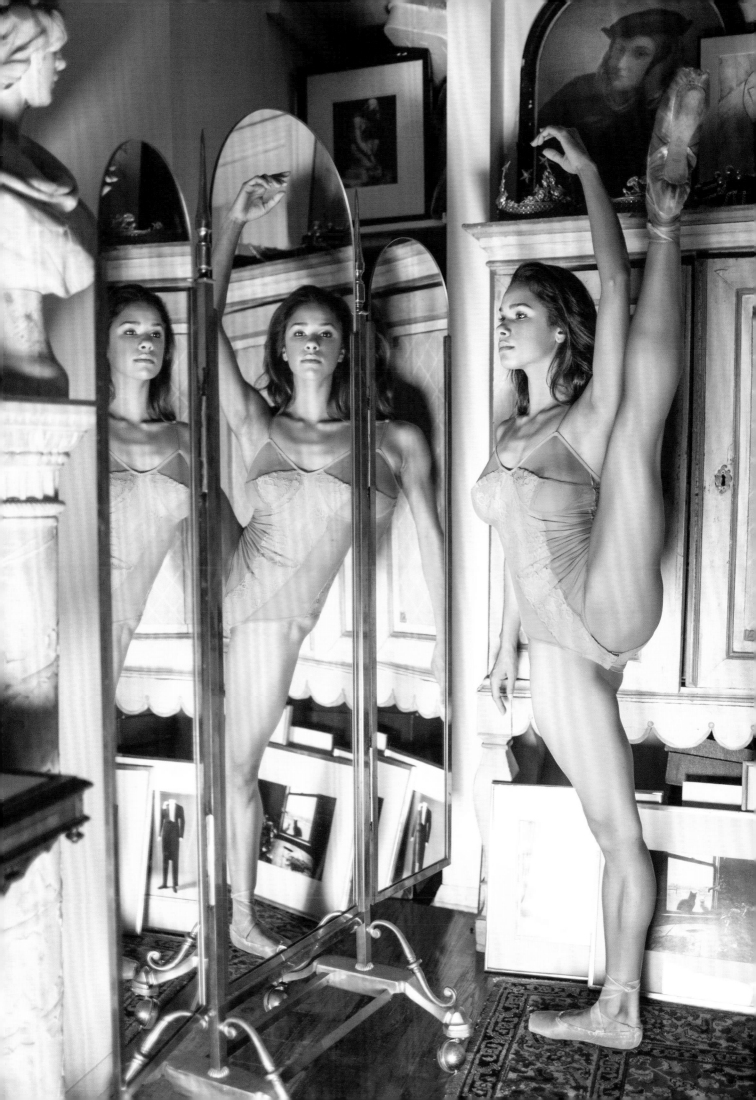

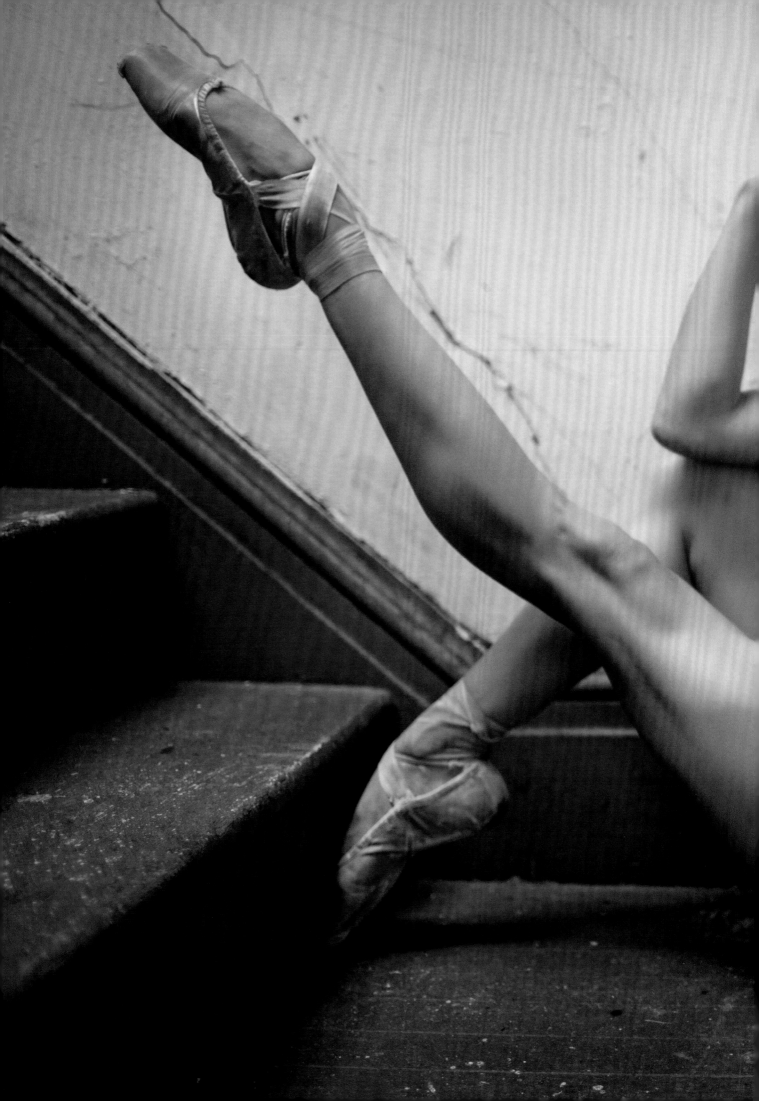

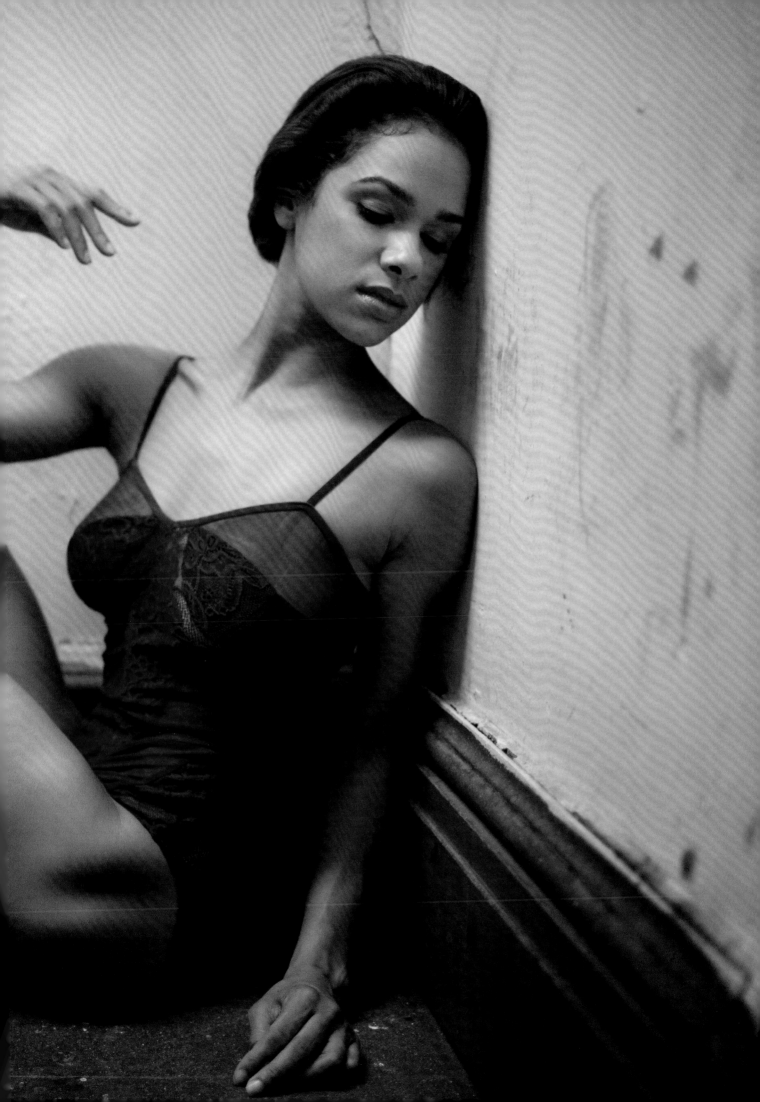

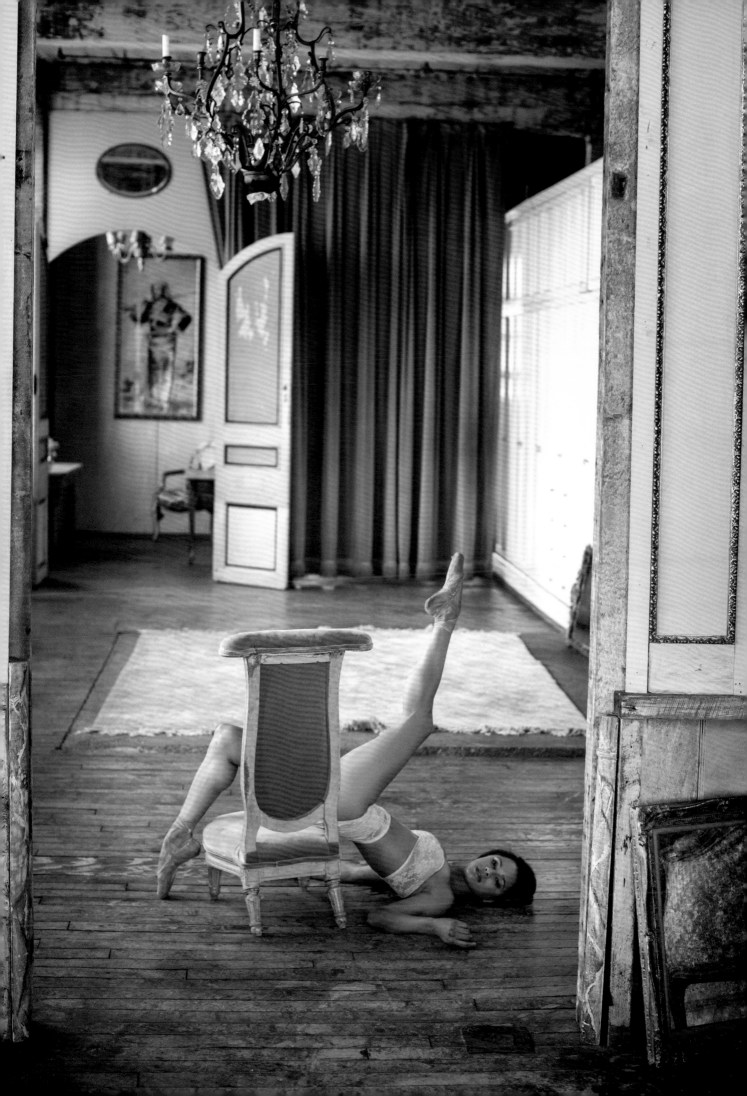

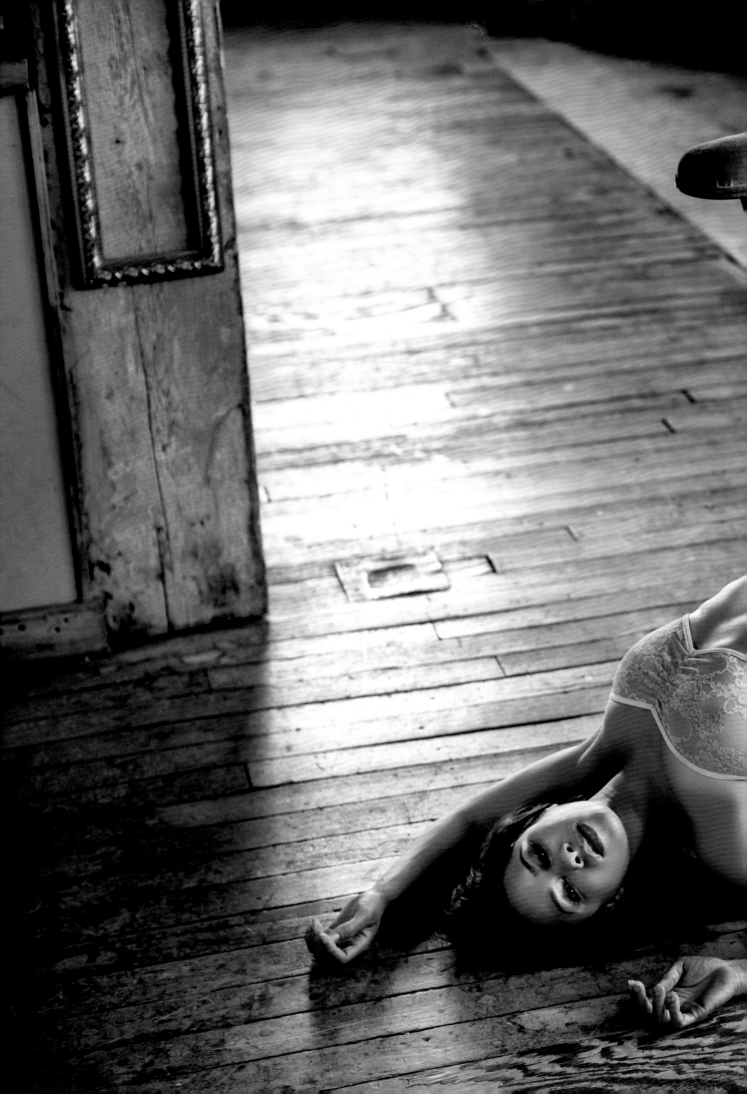

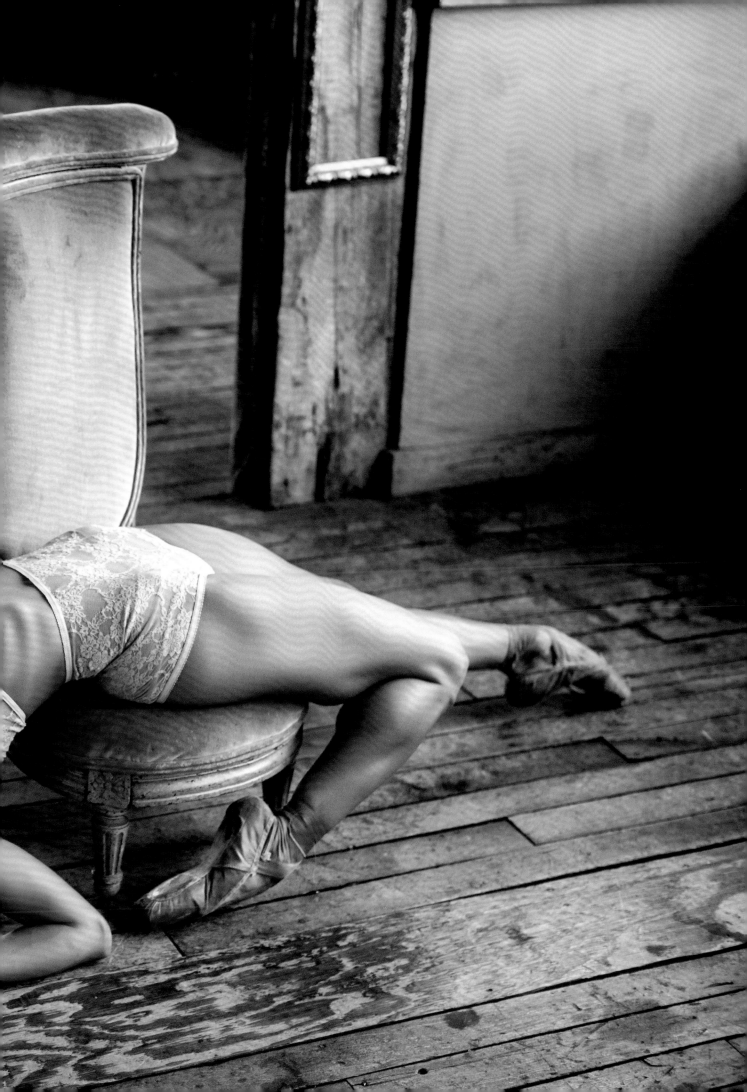

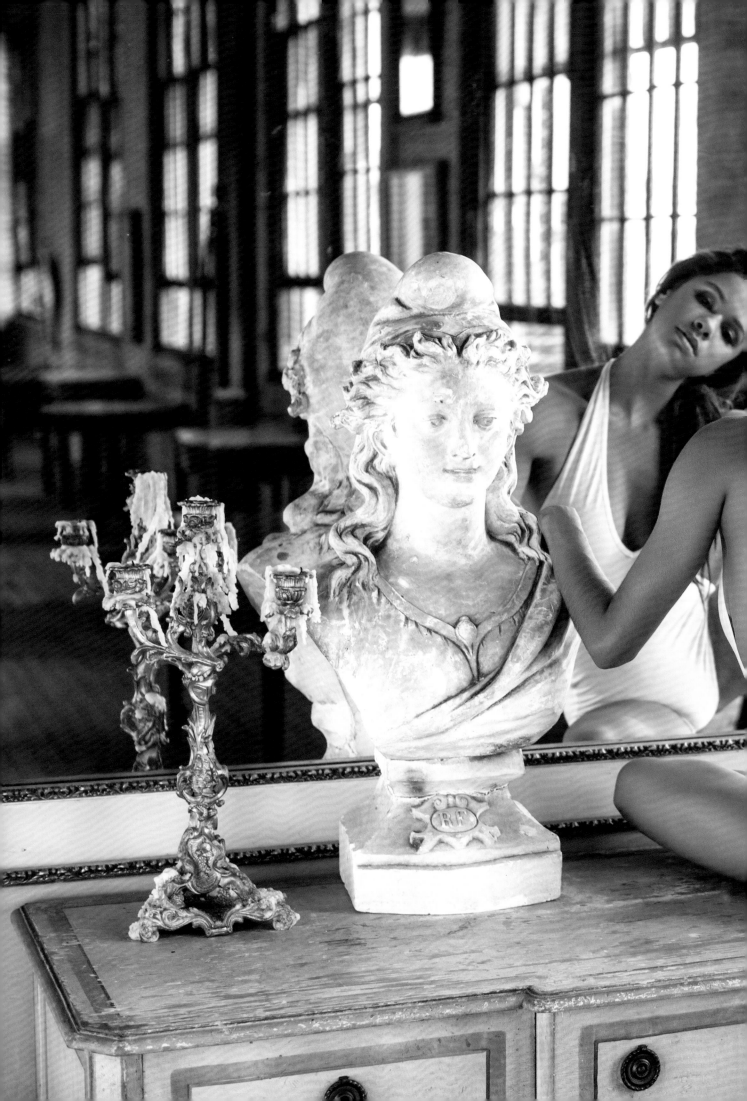

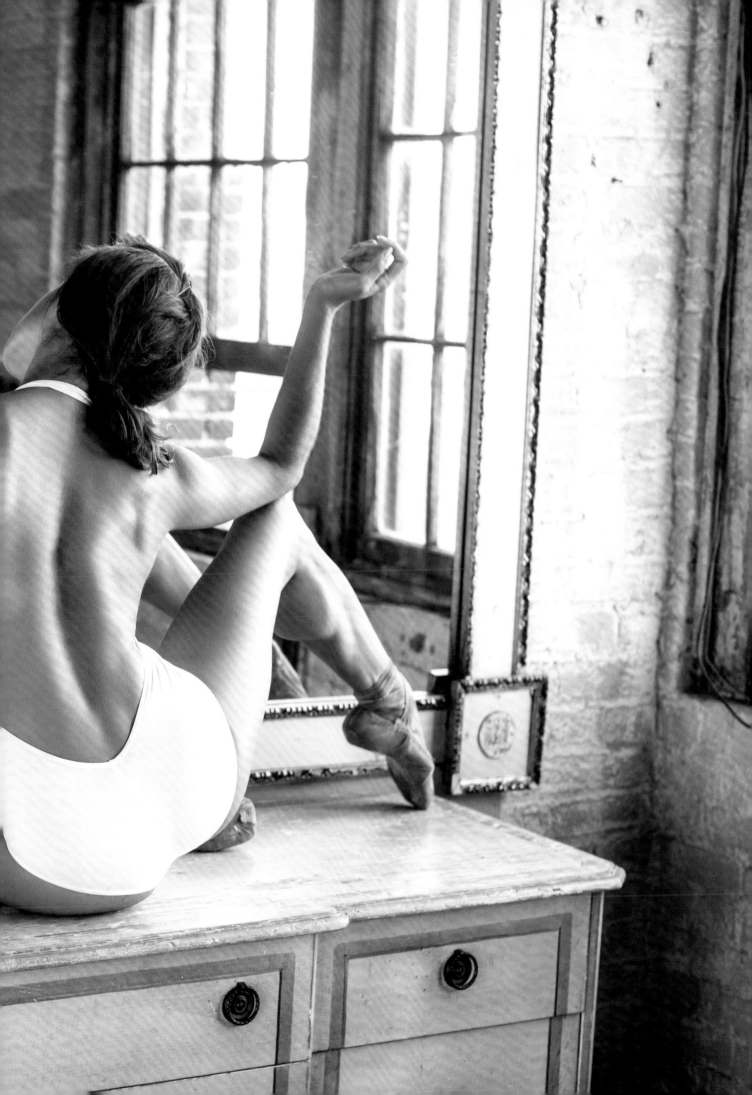

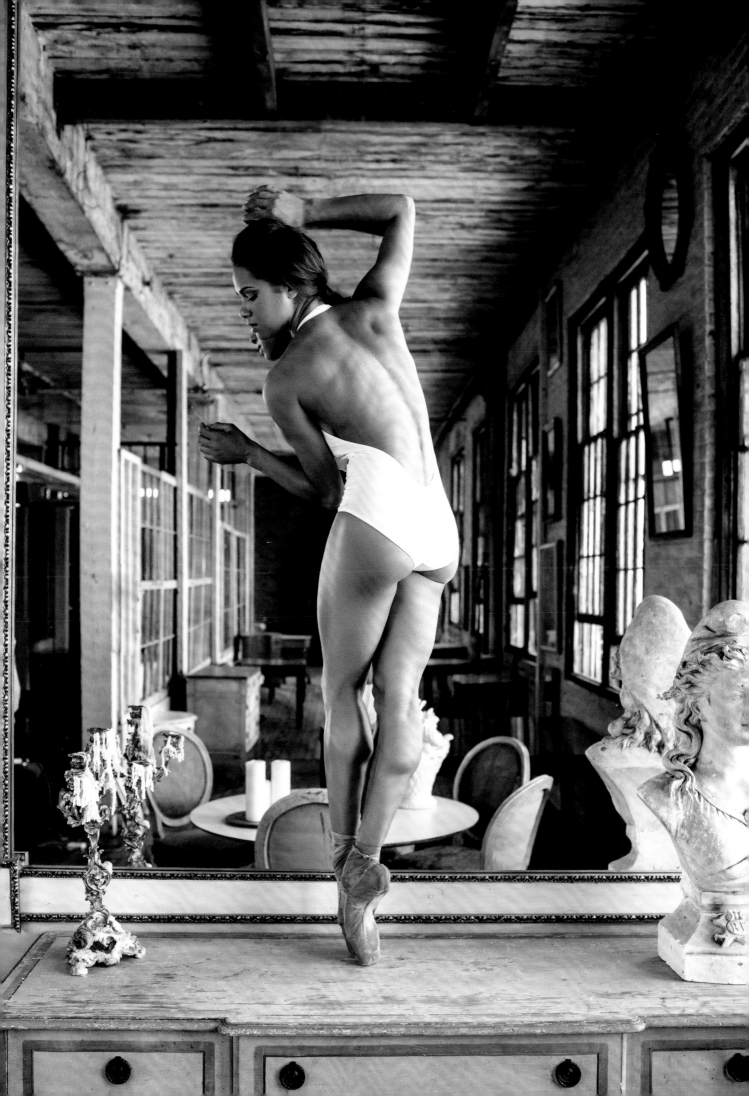

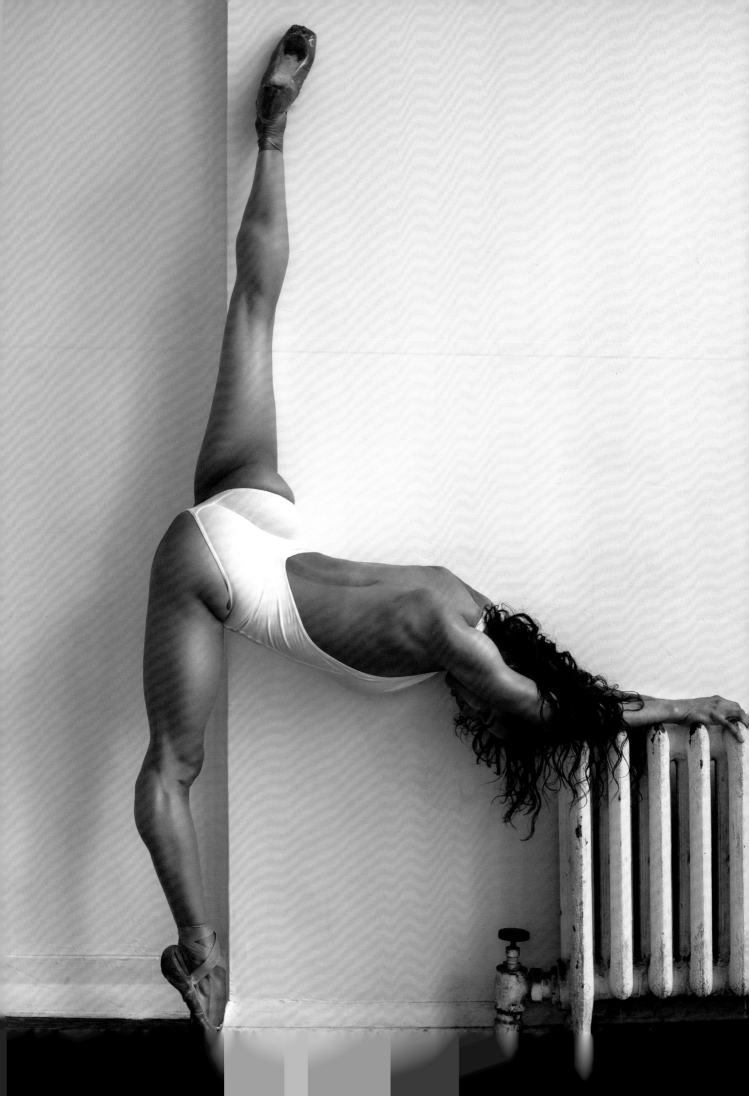

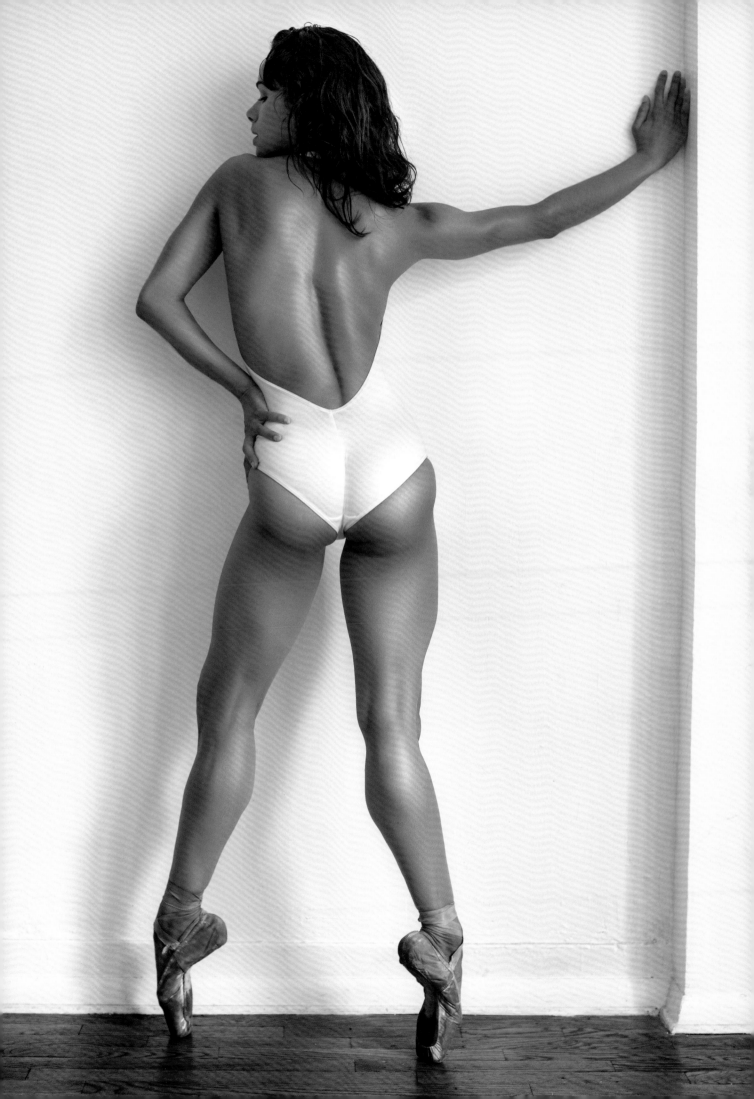

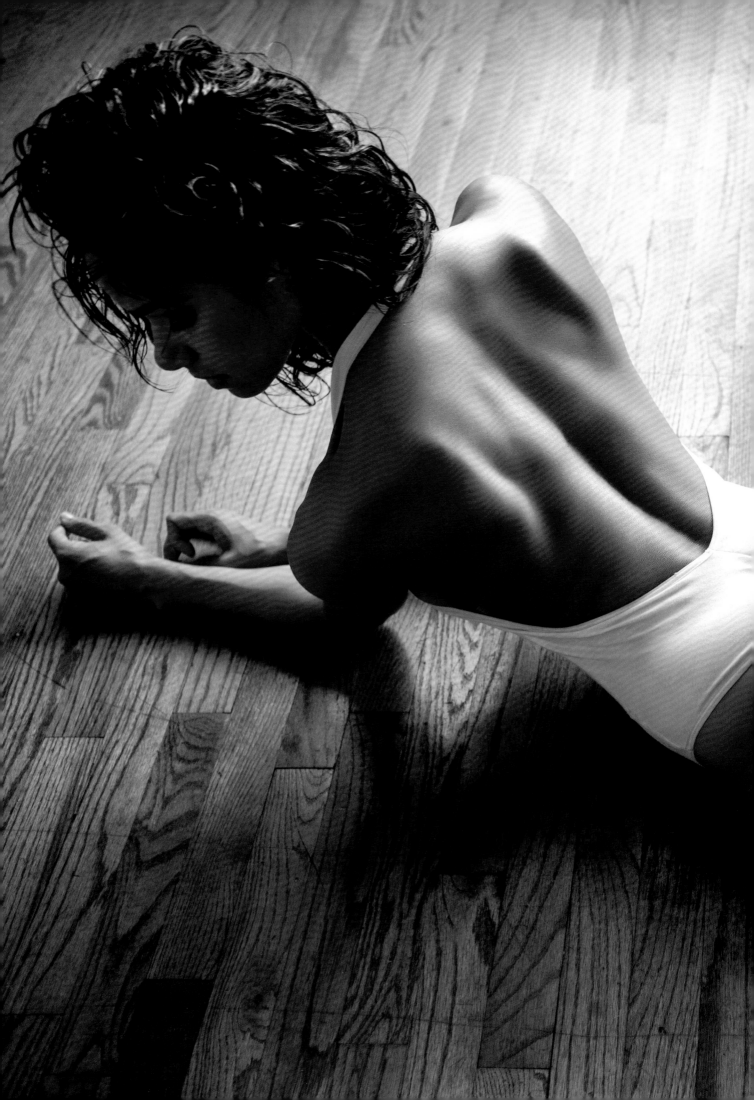

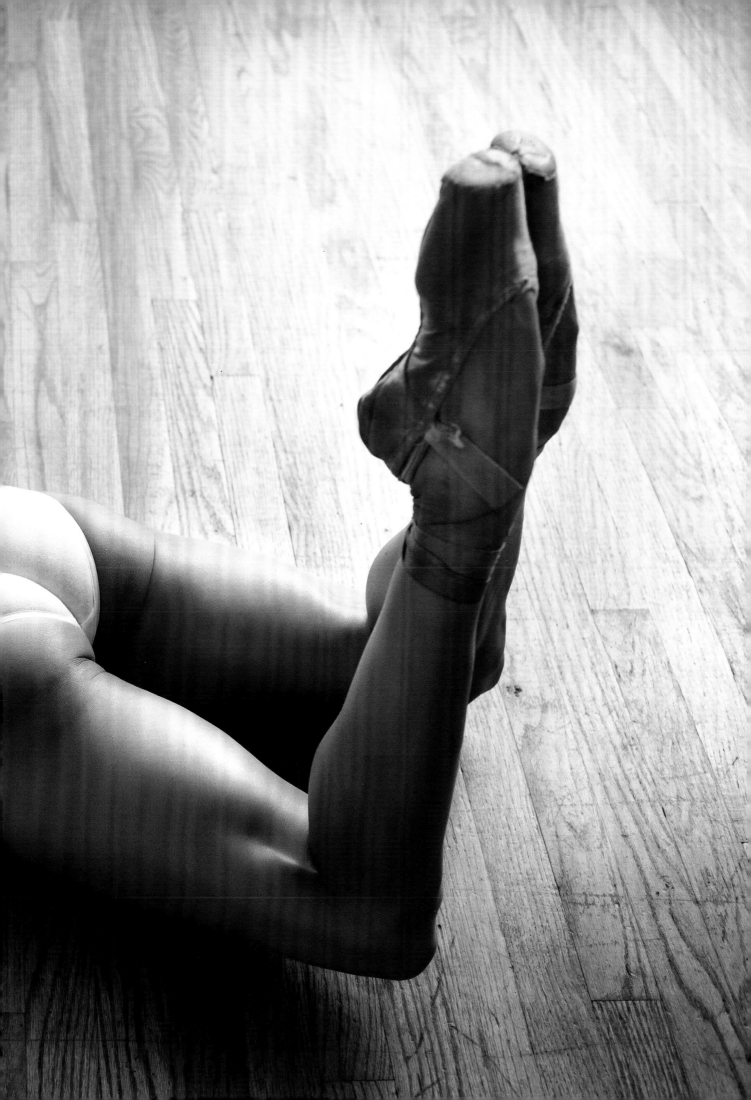

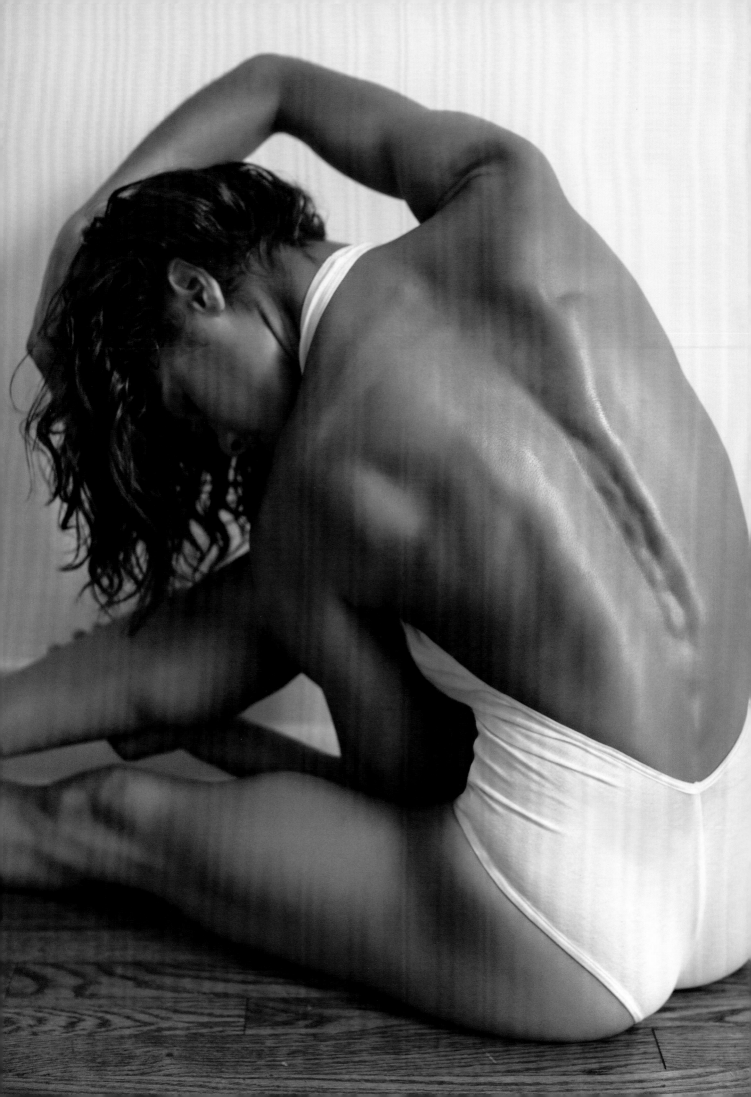

MISTY COPELAND BY GREGG DELMAN

Published by Rizzoli International Publications, Inc.
300 Park Avenue South
New York, NY 10010
www.rizzoliusa.com

Photography © Gregg Delman
Texts © Misty Copeland and Gregg Delman

2018 2019 2020 / 10 9 8 7 6 5 4 3

Publisher: Charles Miers
Designer: Johan Svensson
Editor: Julie Schumacher Grubbs
Production Manager: Kaija Markoe

ISBN: 978-0-8478-4971-0
Printed in China
Library of Congress Control Number: 2015959647

AUTHOR'S ACKNOWLEDGMENTS:

I am extremely grateful to my wife, Gita, for her understanding, support, and love. And of course I am grateful to Misty Copeland, for making this collaboration possible. Thank you to my mom, for her selflessness and guidance; and to my sister, Honey, for always being there. Thank you to Farley Chase, for his patience and perseverance; to Gilda Squire, for opening the door when I came knocking; to my assistant, Mike Howard, for being rock solid; to Karen Schijman, for her flawless style; to Johan Svensson, for creating an artifact; and a very special thanks to Charles Miers, Julie Schumacher Grubbs, and everyone at Rizzoli for seeing this through.

Additional thanks to Mia Booker, Sarah Carstens, John Deen, Maria Pia Gramaglia, Jerry Hoffnagle, Shanta Inshiqaq, Anthony Petrillose, Linda Pricci, Lynn Scrabis, Pam Sommers, Aaron Valentic, and Casey Whalen.

This book is for Charlie.

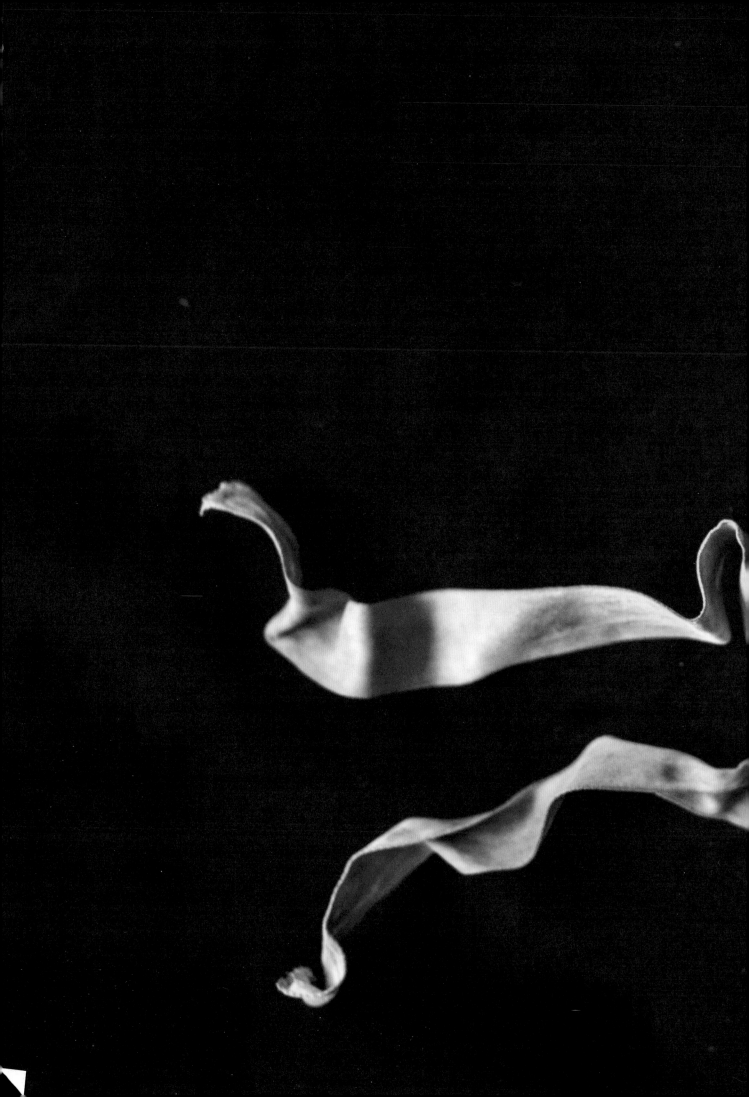